IMAGES
of America

APPLE VALLEY

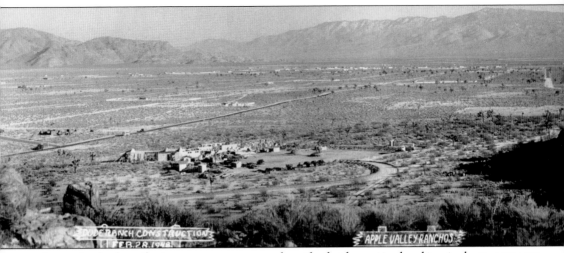

Just under the dry soil exists an enormous natural aquifer that has enticed and inspired entrepreneurs for more than 100 years. (Courtesy Town of Apple Valley.)

ON THE COVER: Newton Bass holds the reins of a horse-drawn buggy borrowed to demonstrate that Apple Valley offered the best of modern life and the past. Please see page 65. (Courtesy Victor Valley College.)

IMAGES
of America

APPLE VALLEY

Michelle Lovato

ARCADIA
PUBLISHING

Published by Arcadia Publishing
Charleston SC, Chicago IL, Portsmouth NH, San Francisco CA

Printed in the United States of America

Library of Congress Catalog Card Number: 2007920161

For all general information contact Arcadia Publishing at:
Telephone 843-853-2070
Fax 843-853-0044
E-mail sales@arcadiapublishing.com
For customer service and orders:
Toll-Free 1-888-313-2665

Visit us on the Internet at www.arcadiapublishing.com

Author Michelle Lovato believes the preservation of history ensures future generations the opportunity to experience the past and to understand, enjoy, and sympathize with our forefathers, our ancestors, and our environment. (Courtesy A Small Media, Large Editorial Consultation.)

CONTENTS

ACKNOWLEDGMENTS

Thanks to Victor Valley College local history librarian Fran Elgin for her willingness to pull then file hundreds of photographs, scores of newspaper and magazine articles, and at least a dozen taped oral interviews on her donated time. Without her help, Images of America: *Apple Valley* would not exist. Her natural curiosity and genuine love of history was critical to the creation of this book. Special thanks are due to Town of Apple Valley public relations representative Kathie Martin, who donated a large collection of *Apple Valley News* photographs as well as an enormous amount of Apple Valley Ranchos information. But these fine women would have nothing to share if not for the willingness of town residents and forefathers, who thought to snap, collect, and share their families' lives with future generations. Thanks also to Stuart Kellogg, reporter for the *Daily Press* who covered Apple Valley over the years. His colorful writing inspired me and many like me to study the area. The photographs in this book were donated by the Victor Valley College, the Town of Apple Valley, and the Mohahve Historical Society.

INTRODUCTION

It took the creative spirit of an entrepreneur to see a future in the vast desert that became Apple Valley. Its southern neighbor, Riverside County, was already enjoying the success of their booming citrus grove population. Big Bear, located to the east, was alive with gold mining, although miners could not reach the mountain burgh without traveling through what would become Apple Valley. Even though the enormous parcels of desert land received only the smallest amount of annual precipitation, natural springs popped up across the area where a massive water table lay silently below the soil.

Among the first Apple Valley residents was a successful Los Angeles real estate professional named Arthur Hull. In 1913, the Hull ranch was well established in the area, and the smart entrepreneur soon convinced Los Angeles real estate promoter Ursula Poates to join him in his new desert adventure. In addition to being credited for naming the area, Poates convinced many future farmers to mine the Apple Valley area for a different sort of product—apples.

Many farmers moved onto the desert floor, but thanks to Poates, two transplanted entrepreneurs would carve their names in history and be cast for future history books as the incredible and colorful legends that made the area famous.

In 1915, Max F. Ihmsen found the desert irresistible. After homesteading 320 acres of land that he turned into a versatile and successful farm, Ihmsen further promoted his farm and the area through the media. The Ihmsen farm raised turkeys and grew peaches and award-winning apples. Ihmsen, who worked simultaneously as the publisher of the *Los Angeles Examiner*, had no trouble publicizing his great success. Not only did Ihmsen apples win awards all over California, but they also became a must-have delicacy for wealthy hotel and restaurant patrons in Los Angeles. In 1926, more than half of all harvested Ihmsen ranch apples weighed more than one-and-a-half pounds each and were shipped to Los Angeles daily.

Meanwhile, Catherine Boynton, famous for her psychic gifts, followed a vision she had seen in several dreams and ended up at "The Healing Knoll," located near what is now known as "The Narrows." Though her first travels to Apple Valley began in 1911, it wasn't until 1915 that Boynton sent her daughter Gwen and friend Mildred Strong, both fresh out of high school, to homestead the land. Over time, Boynton would found Rancho Yucca Loma, a health ranch for some of the country's most famous celebrities.

But Boynton was not alone in her visions of what Apple Valley could become. In the future, Apple Valley became known as the home of the first African American dude ranch, the first nonprofessional working rodeo, and the first intercollegiate rodeo. Time would bring star after star to the forefront, including Jeanne Godshall Abbott, the world-famous female trick rider who was raised on the Ihmsen-Godshall ranch.

Hollywood's elite made the Rancho Yucca Loma a favorite spot to vacation. Clark Gable broke his tooth there while hunting with Frank Rivers, Mildred Strong's son, who drove through a dip too fast. Gable spent a considerable amount of time at Rancho Yucca Loma, and even returned

to Rancho Yucca Loma to grieve for his wife, Carol Lombard, after she died in an airplane crash outside of Las Vegas.

Boxing superstar Joe Louis put the Murray Overall Wearing Dude Ranch on the map when he came to the desert, bringing the struggling black-owned health ranch instant fame and publicity worldwide.

The health-ranch industry and the Hollywood movie industry were outstanding partners, as several successful health ranches rose to their glory and played host to the very famous. Gene Autry loved to vacation at the McCarthy Dude Ranch, a place that hosted Robert Mitchum and Joe Louis in a time still clearly discriminatory. The Circle M Mendel Guest Ranch provided rest and relaxation to those looking for a dry climate for health reasons, and employees of the Pacific Gas and Telephone Company donated part of their wages to keep the Lone Wolf Health Colony running for those who needed a peaceful place to recover from illness.

The guests kept coming through the Depression, World War II, and the decades beyond. By 1953, both Boynton and her daughter Gwen had died, and Rancho Yucca Loma was gutted of its spirit. Long Beach Richmond Oil Company partners Newton Bass and B. J. Westlund bought the declining guest ranch and began pursuing a new vision for Apple Valley—one that would transform the desert once more. Bass and Westlund would develop Apple Valley Ranchos, which helped lay the foundation for the town's infrastructure, businesses, and a new era of celebrity vacations.

Rancho Yucca Loma was the first home of Bass and his family, but when their new, custom house was completed, Bass moved off Rancho Yucca Loma property as the last entrepreneur to call the health ranch home. Bass and Westlund exhibited great marketing prowess creating the future town of Apple Valley. By creating the theme of a Western-style return to the down-home way of life—which many Hollywood elite desired—Bass and Westlund were able to convince Long Beach investors to start businesses in Apple Valley.

Early business owners often kept their full-time employment in Long Beach during the week and made the three-hour trek to Apple Valley on the weekends to pour their own bricks and lay them one by one until their storefronts were complete. Apple Valley drew a variety of construction companies that set up shop in the area to build houses, lay water pipes, and construct other community-related buildings. Early business owners worked in their shops by day and served as area board members at night.

The Apple Valley Inn was one of the crowning achievements of Apple Valley Ranchos. The ultramodern guest hotel with private cabins, tennis courts, a swimming pool, and a private airport across the street drew a new generation of Hollywood favorites to the area. Bass and Westlund spent millions of dollars on publicity materials promoting the return to yesterday theme and successfully lured such stars as Bob Hope, Richard Nixon, Dean Martin, Marilyn Monroe, and Jerry Lewis.

In 1959, Bass and Westlund built the Hilltop House, a 6,000-square-foot mansion on top of Apple Valley's highest hilltop. The Hilltop House had the most modern of conveniences, including a microwave oven, and was used as a getaway for special Apple Valley Inn patrons.

But as time passed, the Apple Valley Ranchos' heyday would transform again, giving way to a new, burgeoning economy and a sizable established population. In 1988, the Town of Apple Valley was incorporated, and its first town council was established. Despite the eventual retirement and death of Bass and Westlund, Apple Valley continued to grow in both population and industry, soon erasing nearly all signs of early farm and business life once alive on the desert floor. Mega shopping centers and enormous housing tracts snuggled up to the stately Western buildings known to the ghosts of its past as home. But the spirit of those who defined Apple Valley and who blessed the town with its great wealth of history lingers in the winds that brush across the desert.

One

NATIVE AMERICANS

In addition to footprints and primitive tools, thousands of petroglyphs were found near water in the Mojave Desert. Native American nations and their predecessors communicated with these small designs carved into stone to tell stories and pass along the history of the strange and harsh environment. (Courtesy Town of Apple Valley.)

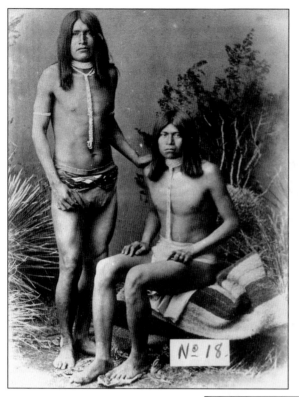

Stone tools, arrowheads, and beads found in the late 1980s along Apple Valley Road are evidence of Native American trade routes in the Mojave Desert. Beads and shells unearthed during a construction project suggest trade with other California tribes. Apple Valley appears to be the home of two tribes: the Paiutes and the Serranos. Both were peaceful. (Courtesy Town of Apple Valley.)

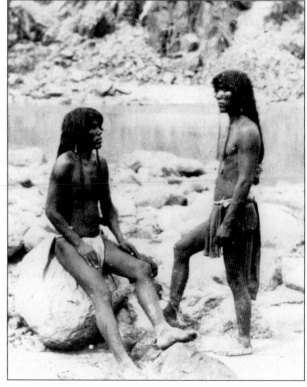

Historians believe that Serrano Indians lived in small, loosely formed groups and that many of them were kidnapped by travelers along the Spanish Trail. Many Native American men were killed, and women and children were sold to California's and New Mexico's missions and ranchos. Most Serrano Indians were absorbed by the Spanish culture and forced into positions of servitude. The Native Americans pictured helped guide an 1871 expedition led by Timothy H. O'Sullivan. (Courtesy Town of Apple Valley.)

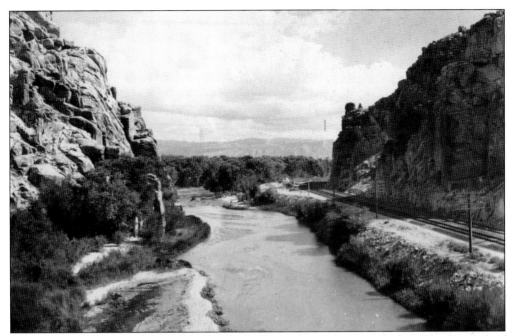

The Mojave River originates at Silverwood Lake, located in the mountains several miles south of Apple Valley, and is one of two rivers in the world that flows away from the ocean. The Mojave flows underground most of the time. (Courtesy Mohahve Historical Society.)

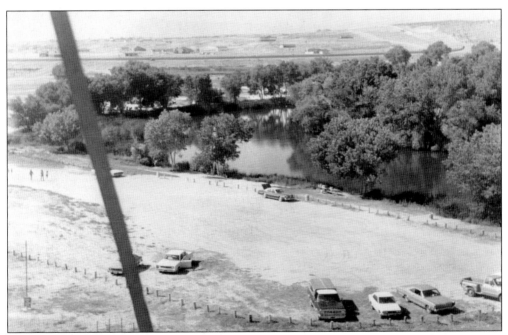

The Mojave River runs through Apple Valley and turns west into Victorville through the narrows. Native Americans, wild game, and wild horses populated the desert before the white man arrived. The horses were said to be descendants of mustangs stolen along early trade routes through the area. (Courtesy Town of Apple Valley.)

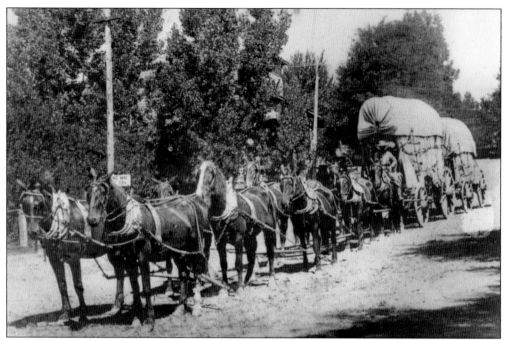

Ten horses pull a two-wagon payload of supplies through Apple Valley to Big Bear in 1903. (Courtesy Town of Apple Valley.)

Credited as the first white man to build a house in the area, 17-year-old Silas Cox arrived with little more than a herd of cattle and some horses. Soon the Mojave Desert was dotted with hearty entrepreneurs looking to start new lives in the desert. (Courtesy Victor Valley College.)

Two

PLANTING APPLE VALLEY

Early settlers were the first group to transform the High Desert into what would become Apple Valley. Settlers camped in makeshift tents until they were able to build homes. (Courtesy Victor Valley College.)

Ursula Poates worked as a locator and real estate agent for a Los Angeles real estate office. She assisted customers who wanted to relocate to Apple Valley and was known to screen potential residents for their worth as good neighbors before introducing them to her desert home. Poates lived across the street from wealthy rancher Arthur Hull, an influential real estate developer and promoter of Apple Valley. In total, Poates owned about 1,440 acres. (Courtesy Victor Valley College.)

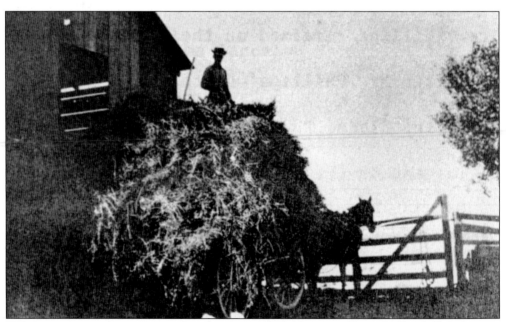

Wil Foster, an area farmer, is seen here haying in 1910. (Courtesy Victor Valley College.)

Early area farmers banked on the idea that they could make the dry desert earth produce the kind of wealth enjoyed by "orange belt" farmers in nearby Riverside. Experts are not sure if this 1890s apple orchard was located in what was to become Apple Valley or neighboring Hesperia. (Courtesy San Bernardino County Museum.)

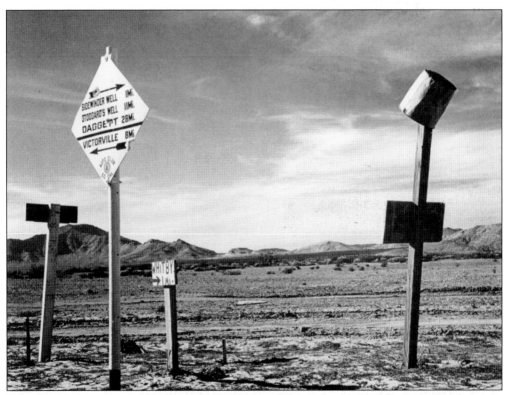

Even though farming would become the first financial boom for Apple Valley, many settlers were owners or workers in area mines. Members of the John Carroll family were among the earliest Apple Valley settlers. John was part owner of the Sidewinder Mine, located at the north end of the High Desert. The Carroll property and the Sidewinder Mine later became known as the Bell Mountain District. This sign displays the distance between the Sidewinder Mine and neighboring Victorville. (Courtesy Mohahve Historical Society.)

Elmore Corwin, Civil War veteran and Los Angeles resident, and his wife, Harriet, moved to Apple Valley in 1908 after being advised by his doctor to relocate to a drier climate. Elmore, who died his 90s, was a prominent member of society and helped to map out the future of early Apple Valley success. This photograph shows Harriet in her later years. (Courtesy Mohahve Historical Society.)

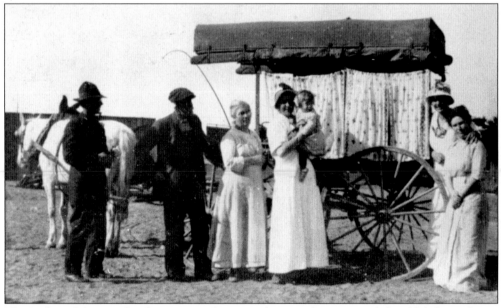

The Lytle and Corwin families, seen in this 1914 photograph got around the old-fashioned way: with a horse-drawn surrey. As they stand waiting for the required time to snap a good photograph, their attention appears to be focused on the baby, who would one day grow up and move the Apple Valley farmers' vision into the future. (Courtesy Mohahve Historical Society.)

This 1914 photograph of Harriet Corwin shows her tending to one of her peach trees, which were commonly grown in Apple Valley. (Courtesy Mohahve Historical Society.)

The first school built in Apple Valley was located on the land of the John Carroll family and was erected in 1908. Carroll was partial owner of the Sidewinder Mine north of Apple Valley and built the school for five area kids to attend. Because the law stated that six students must be enrolled for a school to be built, Ester Larsen of Long Beach was "borrowed" and enrolled in the school to meet the requirements of the law. (Courtesy Mohahve Historical Society.)

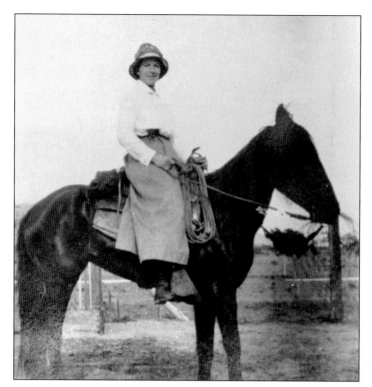

The Bell Mountain School was built in 1913 at the north end of Apple Valley on Elmore Corwin's land. The two schools operated on each end of Apple Valley until 1940 when Yucca Loma Elementary School was built. Bess Bronson (pictured) was the teacher at the Bell Mountain School.

Bess and William Bronson homesteaded in Apple Valley after Ursula Poates helped them relocate from the Los Angeles area. William is believed to have found a job with the County of San Bernardino clearing brush, then later at the Victor ranch in Apple Valley, picking apples. (Courtesy Mohahve Historical Society.)

Three

BIG RANCHES

In 1914, Englishman William E. Hitchcock and partner Ed Grimes brought their cattle herd from Holcomb Valley near Big Bear to winter in Apple Valley, a practice that lasted 20 years. Hitchcock was in the meatpacking business, and his ranch was one of largest in the area. His Apple Valley ranch was located at the southwest corner of what is now Highway 18 and Navajo Road. This is his 1914 ranch house, which was delivered precut and fitted. (Courtesy Mohahve Historical Society.)

The Hitchcock family was well equipped with horses and supplies. They were important to Apple Valley because they employed many of the people who built the first infrastructure in the area. Pictured is the Hitchcock ranch house. (Courtesy Mohahve Historical Society.)

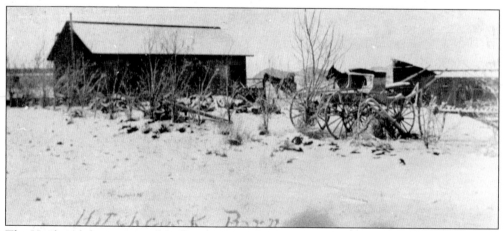

The Hitchcock barn was well used in its time. A horse and buggy stand ready for use in the foreground of this photograph, and a horse wanders around in the background. This photograph was likely shot because of the snowfall on the ground. Snow was not a regular occurrence in the desert. (Courtesy Mohahve Historical Society.)

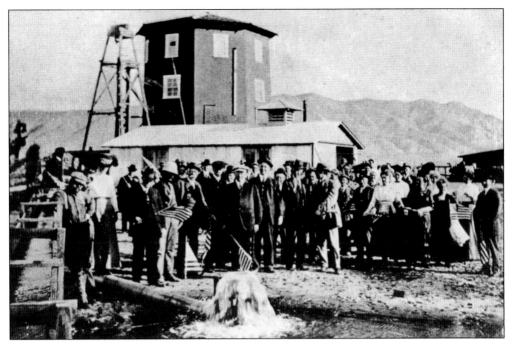

The first watering trough was developed by both Hitchcock and Grime and was located on the northeast corner of the White ranch, now the corner of Kiowa and Bear Valley Roads. (Courtesy Mohahve Historical Society.)

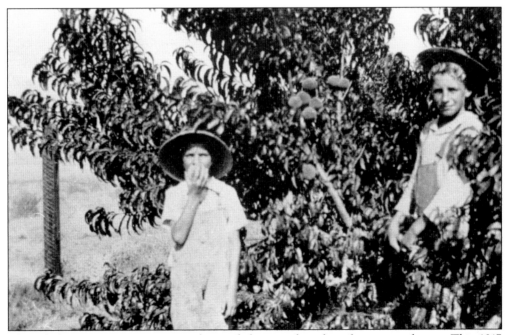

These kids are enjoying warm weather and the succulent fruit from a peach tree. This 1917 photograph was taken on the Hitchcock ranch. (Courtesy Mohahve Historical Society.)

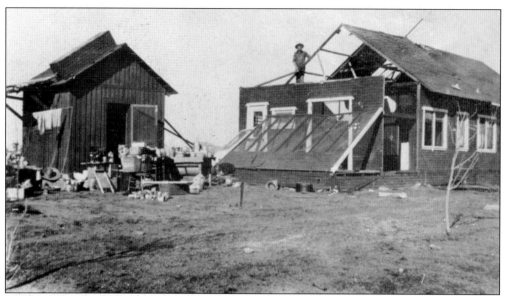

The High Desert is known for its ferocious wind. This 1915 shot of the Hitchcock ranch shows tremendous damage sustained after a wind storm. To the left of the photograph, a large collection of household items awaits Hitchcock's repair. (Courtesy Mohahve Historical Society.)

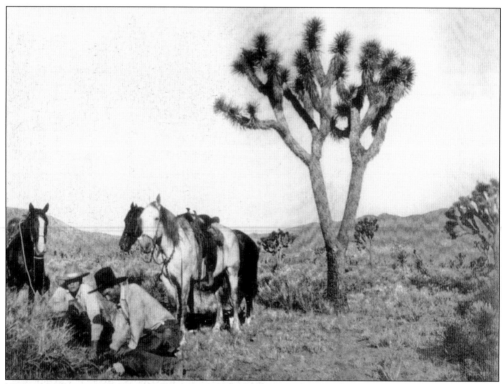

Native American cowboy Jim Deaver and coworker Frank Rivers work to rescue an animal in a remote location. The Apple Valley area and the High Desert range provided the perfect conditions for farmers to let their cattle winter. (Courtesy Town of Apple Valley.)

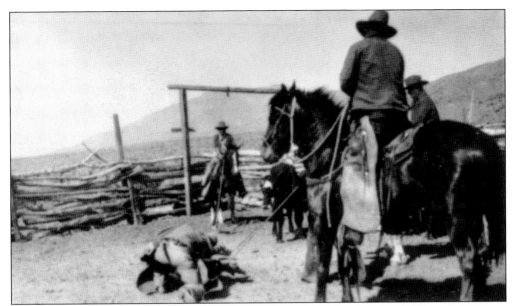

Ranch chores were a fact of life in the early part of the 1900s. Cowboys worked together to rope and brand cattle. These four cowboys are branding at the McGinnis Deep Creek headquarters in 1933. (Courtesy Town of Apple Valley.)

Pictured is Jimmy Monahan. According to early settler Gertie Bowen, the Monahan ranch was a central point where Native Americans often gathered. Bowen said that a Native American burial ground was located across from his farm and that the Bowen children found arrowheads there. A Native American garden was located beyond the burial ground. (Courtesy Mohahve Historical Society.)

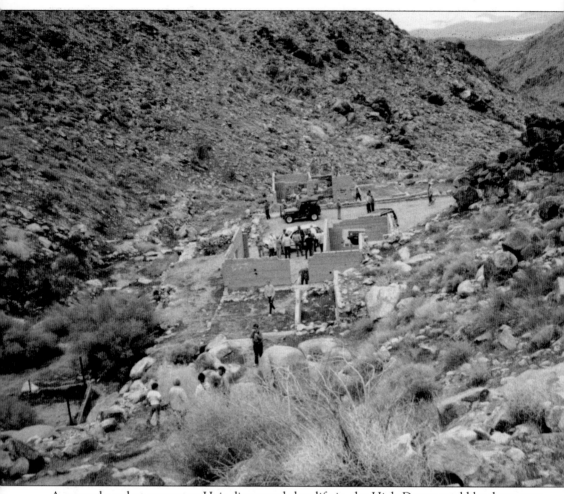

A man whose last name was Hair discovered that life in the High Desert could be dangerous. In 1913, Hair built a group of stone buildings in the canyons to the south of Apple Valley. A natural spring flowed through his property and was commonly used by ranchers as a place to water their cattle. Hair ran into a bit of trouble after he fenced off the canyon, which prevented ranchers from accessing the spring. Hair's son Dan said that after his father had been missing for a week, family members traveled to the spring and found Hair dead from a bullet wound to his heart. While Hair was lying in the bottom of the gulch, his buildings were burned to the ground. (Courtesy Victor Valley College.)

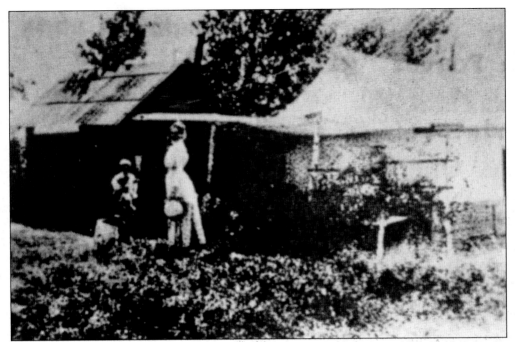

Early settlers thrived on crops raised on their own farms. This woman and her child appear to be gathering fruit. (Courtesy Victor Valley College.)

The Strong family, whose home is pictured, was one of many who capitalized on the free land the government offered through the Homestead Act of 1862, which allowed ownership of 160 acres with the agreement that the new land owner live on the property for three years. In 1910, the Homestead Act was expanded and offered 320 acres of land if one-eighth of the land was cultivated within three years. Full title was granted after five years of living on the property. (Courtesy Victor Valley College.)

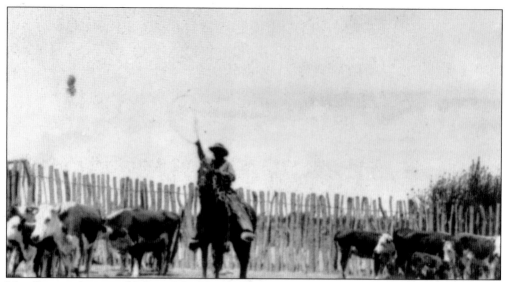

Max Ihmsen, former publisher of the *Los Angeles Examiner*, developed 320 acres of prizewinning apples and pears and cared for a sizeable cattle ranch. This photograph was taken as some of his employees were dehorning cattle in the spring of 1933. (Courtesy Mohahve Historical Society.)

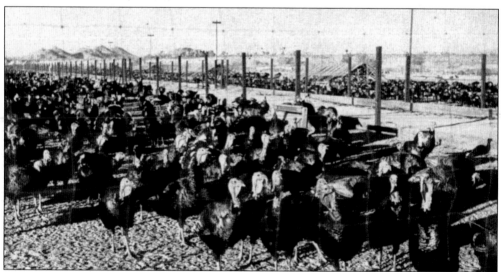

Little did Max Ihmsen know that when he decided to raise turkeys, the Ihmsen-Godshall ranch later would become more famous for its turkeys than for its beautiful oversize apples. (Courtesy Mohahve Historical Society.)

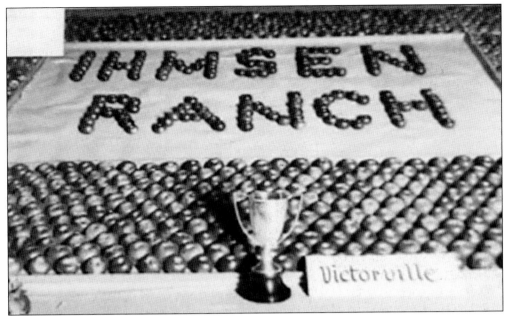

Through the generations, the Ihmsen family became an integral piece of Apple Valley history. A display of Ihmsen-ranch apples are highlighted by a first place prize, won in Watsonville, Victorville, and at the Los Angeles County Fair in Pomona in the 1920s. And thanks to Ihmsen's former publishing experience, his fruit and the blooming Apple Valley desert gained considerable fame. (Courtesy Mohahve Historical Society.)

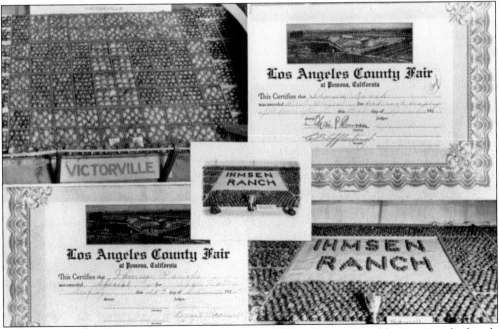

By 1925, Apple Valley was a large and celebrated supplier of fruit to wealthy Los Angeles hotels and restaurants. In 1926, Ihmsen's apples, many of which weighed one and a half pounds, were shown at a Riverside fair. Ihmsen apples were delivered to Los Angeles fruit markets within 12 hours of being picked from the tree. (Courtesy Mohahve Historical Society.)

This photograph shows the Cal Godshall ranch. Ihmsen's daughter Josephine married Cal Godshall, whom she met at Resting Springs, located near Death Valley. The young couple moved onto the Ihmsen ranch, where Cal worked as the foreman. (Courtesy Mohahve Historical Society.)

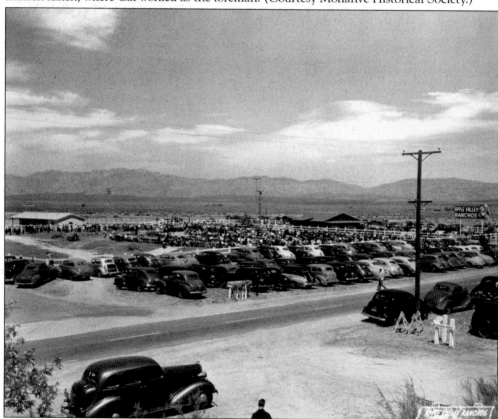

Resident Cal Godshall created the first Nonprofessional Working Cowboys Rodeo, an annual event that drew as many as 10,000 people. Among the attendees were Gene Autry, Harry Carey, Clark Gable, Edgar Bergen, Fay Rae, and Will Rogers. (Courtesy Mohahve Historical Society.)

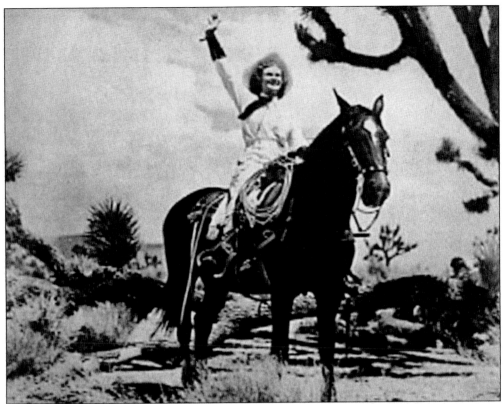

World-renowned as a top rodeo trick rider, Jeannie Godshall grew up around the Godshall rodeos. The daughter of Josephine Ihmsen and Cal Godshall, she often helped host her father's rodeo events. (Courtesy Town of Apple Valley.)

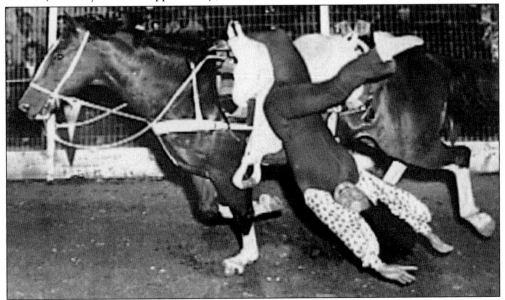

Jeannie Godshall is also credited for starting the first intercollegiate rodeo, which featured college students from across the Southwest. (Courtesy Town of Apple Valley.)

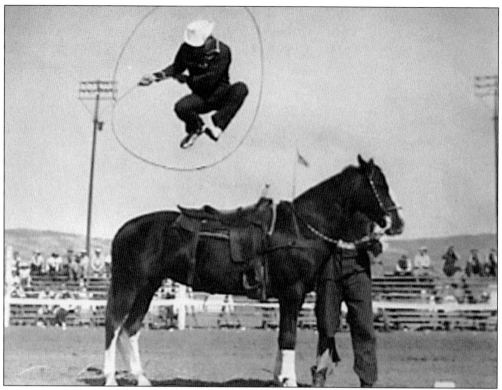

Known as the "flying cowgirl," Jeannie Godshall married her male professional counterpart, Buck Abbott, a recognized champion trick rider, bull rider, and cattle roper. Abbott performed many stunning horseback-riding tricks which included both jumping through his lasso and dragging himself along the side of his moving horse. (Courtesy Town of Apple Valley.)

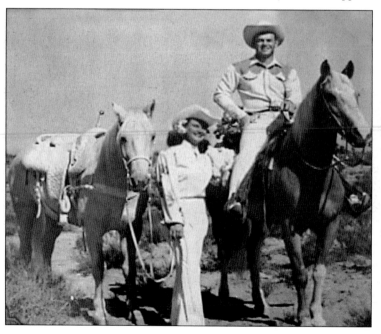

Jeannie Godshall's road act covered 11,000 miles and 30 cities. Future Apple Valley promoters Newton Bass and Bud Westlund paid the Abbotts a $500 monthly fee to promote their hometown as they toured the United States. (Courtesy Town of Apple Valley.)

Four

GUEST RANCHES

The Great Depression shook up Apple Valley, forcing the largest farms to make drastic cutbacks. Among those affected was the Ihmsen-Godshall ranch, which cut back from 320 to 80 acres of apples. Further devastation took place in 1931 when Apple Valley orchards suffered from pear blight, a massive crop failure caused by sudden freezing temperatures. Farming in Apple Valley would never return to its former glory, but entrepreneurs found other ways to make money off the land. (Courtesy Victor Valley College.)

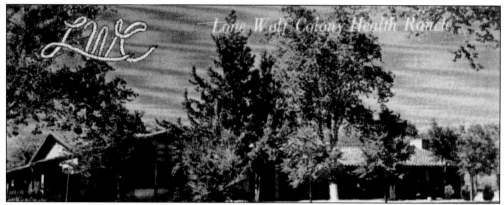

The Lone Wolf Colony opened in 1922, becoming one of the first guest ranches in the area. The Lone Wolf Colony was inspired by World War I veteran Sam Caldwell, who suffered from nerve-gas exposure. (Courtesy Mohahve Historical Society.)

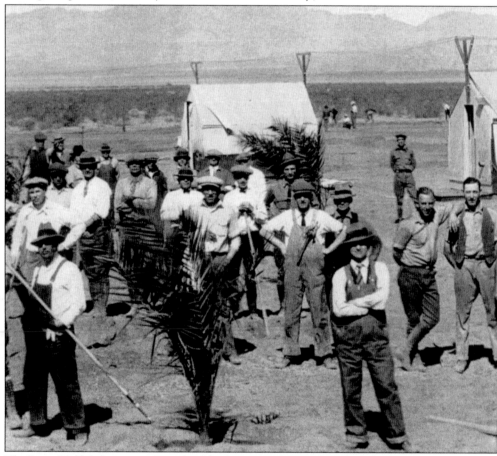

The Lone Wolf Colony served as a health sanitarium for Pacific Telephone and Western Electric Company and was paid for by voluntary deductions of company employees. The facility is still open today and serves as a charity outlet for kids who would not be able to visit a health ranch otherwise. It is the only health ranch still in existence in Apple Valley. (Courtesy Mohahve Historical Society.)

32

The McCarthy Guest Ranch, located in northeast Apple Valley, was started in 1933 but did not see much fame until actor Robert Mitchum happened by while filming the movie *G.I. Joe*. The ranch encompassed 63 acres and was home to 16 horses and 300 head of cattle. It had 13 buildings and hosted up to 80 guests at a time. (Courtesy Mohahve Historical Society.)

In addition to seeking relaxation, many guests stayed at the McCarthy Guest Ranch after being prescribed a visit by their doctors. Patients there suffered from arthritis, asthma, and a variety of other breathing-related ailments. (Courtesy Mohahve Historical Society.)

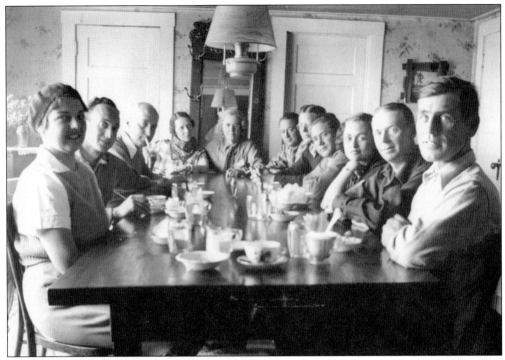

Irene McCarthy served meals to her guests across a long, inviting, dining room table. (Courtesy Mohahve Historical Society.)

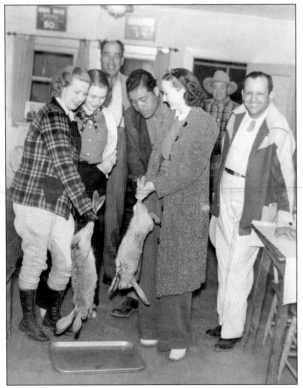

Apple Valley became very popular with the moviemaking industry through the 1960s. Movie icon Gene Autry and the Tumbling Tumbleweeds loved staying and playing at the McCarthy Guest Ranch. Boxing champion Joe Louis is seen in the center of his photograph after a rabbit hunt. (Courtesy Mohahve Historical Society.)

The High Desert was inspiring to nearby Hollywood and was the backdrop of more than 20 motion pictures. (Courtesy Town of Apple Valley.)

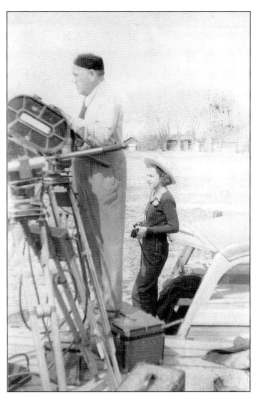

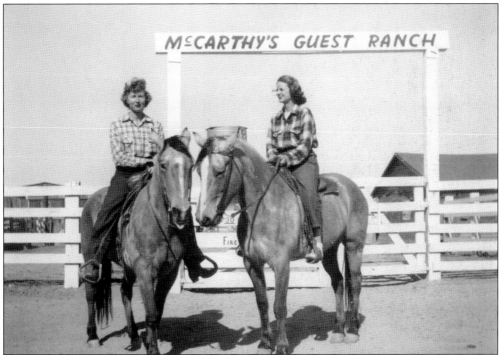

The McCarthy Guest Ranch was known for its family atmosphere and homey feel. (Courtesy Mohahve Historical Society.)

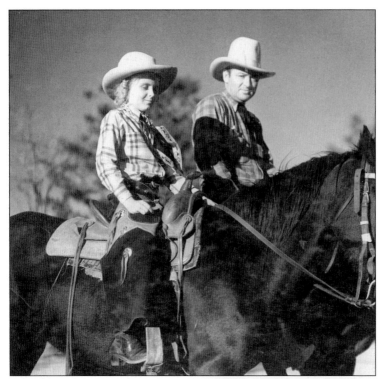

George and Irene McCarthy couldn't keep their marriage together, and the couple finally decided to divorce. George moved to another part of Apple Valley and began his own guest ranch. He is pictured with a visitor to the ranch. (Courtesy Mohahve Historical Society.)

Irene McCarthy (pictured) kept the original ranch, and the two ex-spouses competed for business. Newspaper owner and longtime resident Eva Conrad said that things at the McCarthy Guest Ranch were never the same after the divorce. The McCarthy Guest Ranch eventually became the Apple Valley Airport. (Courtesy Mohahve Historical Society.)

Eva Conrad and her husband, Lloyd, owned and operated the *Apple Valley News.* Eva was a former radio publicity writer, and Lloyd was a former *Los Angeles Times* reporter. In this photograph, Lloyd runs the couple's newspaper press. (Courtesy Town of Apple Valley.)

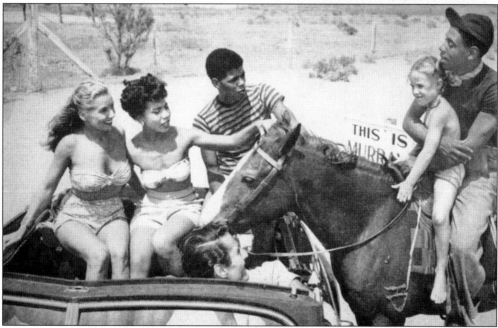

Apple Valley land patents were issued to African Americans starting in 1914 in the northwest section of Apple Valley known as Bell Mountain. By World War II, the area was home to a convenience store, a post office, a feed store, a school built by the Corwins, and two churches. Local resident Arthur Cook convinced Los Angeles businessman and friend Nolie Murray to move to the desert. Murray's wife, Lela, wanted to move for health reasons and did so, while Nolie stayed behind for a time to run the couple's successful Los Angeles pool hall and cigar store. He later moved to the guest ranch with his wife. This photograph was used in an *Ebony* magazine feature story to illustrate racial harmony at the Murray Dude Ranch. (Courtesy Victor Valley College.)

Lela Murray, a nurse, and her husband dreamed of opening a health sanitarium for ill and financially challenged children of all races. The Murrays' ranch struggled to make ends meet until a late-1930s visit from world heavyweight boxing champion Joe Louis. (Courtesy Victor Valley College.)

In 1937, boxer Joe Louis attended the Godshall Rodeo and stole the attention of a *Life* magazine crew, which was on-site to gather material for a feature on the popular rodeo. *Life* photographers learned that Louis was staying at the Murray Dude Ranch a few miles away. Images of the ranch were not archived well, and time has swallowed most of them. These photographs, however, were preserved in the pages of *Ebony* magazine for all to enjoy. (Courtesy Victor Valley College.)

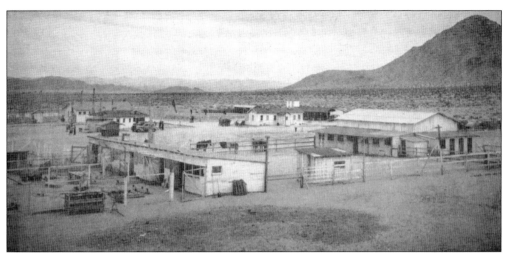

The Murrays' Overall Wearing Dude Ranch had 20 buildings during its heyday, as well as a swimming pool, tennis courts, stables, ball field, and dining room. Nolie and Lela are said to have pushed their piano up a large hill on their property to use in sunrise services. A cross placed by the Murray family and its supporters still stands on Catholic Hill to commemorate their many church services. (Courtesy Victor Valley College.)

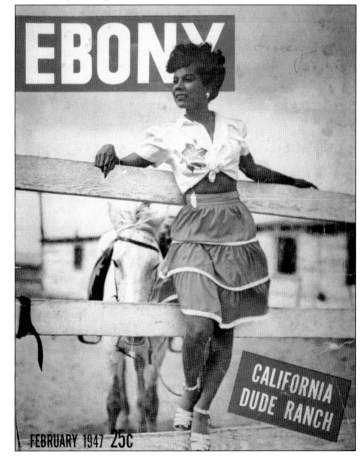

After Louis's visit and the exposure in *Life* magazine, the Murrays' Overall Wearing Dude Ranch became very profitable and popular, hosting, among others, boxing champion Henry Armstrong; Mary McLeod Bethune, who founded Florida's Bethune College; Bill "Bojangles" Robinson; and Lena Horn. Hollywood producers shot *Bronze Buckaroo* and *Harlem Rides the Range* at the Murrays' ranch. Both *Life* and *Ebony* magazines wrote cover stories about the ranch, which was the only African American dude ranch in the United States during the first half of the 20th century. (Courtesy Victor Valley College.)

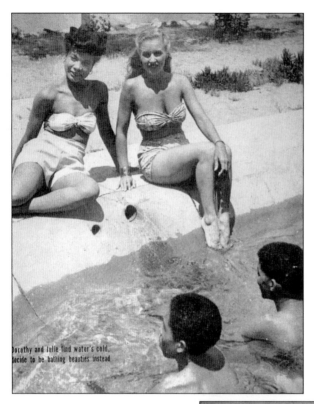

Dorothy and Julie find water's cold, decide to be bathing beauties instead

When Lela Murray, who sat on the Victorville Chamber of Commerce Board of Directors, found out that during World War II, a USO for white soldiers only would be erected in neighboring Victorville, she protested on behalf of black soldiers stationed at a local air field. The Murray ranch responded to the closed-minded USO requirements by opening its doors to anyone interested in the dances and other events held there. (Courtesy Victor Valley College.)

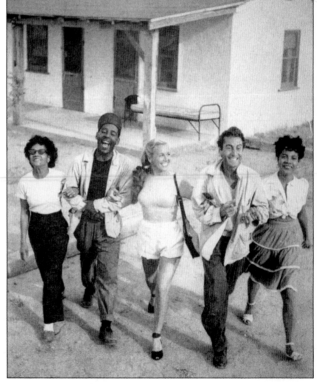

The Murrays' Overall Wearing Dude Ranch was sold to singing superstar Pearl Bailey in 1955. Lela died in 1949, and Nolie moved onto a five-acre piece of Bailey's new ranch. He died in 1958. Bailey renamed the ranch Lazy P. Bailey. By 1988, the Murray/Bailey ranch was gone from Apple Valley's landscape, leaving only photographs to tell its story. (Courtesy Victor Valley College.)

Rancho Yucca Loma was founded by Catherine Boynton, who enjoyed considerable fame for being a naturopath, psychic, and spiritual healer. Boynton, who lived in Los Angeles, saw a place of spiritual healing in a series of dreams and visions. (Courtesy Victor Valley College.)

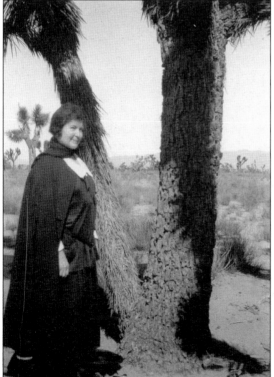

Years before she arrived in Apple Valley, Boynton received a calling to create a spiritual destination in a dry desert climate. In 1911, she traveled to Apple Valley and came upon a spot on the Joshua-tree-dotted land and proclaimed that that very knoll was what she had seen in her visions. (Courtesy Victor Valley College.)

Boynton returned to Los Angeles and in 1915 sent her daughter Gwen and Gwen's friend Mildred Strong to homestead 320 acres—and later an additional 880 acres. This photograph of "Gwennie" in the 1920s shows her youth and spirit. (Courtesy Victor Valley College.)

Mildred Strong, daughter of Frank Strong, met and married her husband in the desert and then raised her family in and around Rancho Yucca Loma. This photograph was taken in the 1920s. (Courtesy Victor Valley College.)

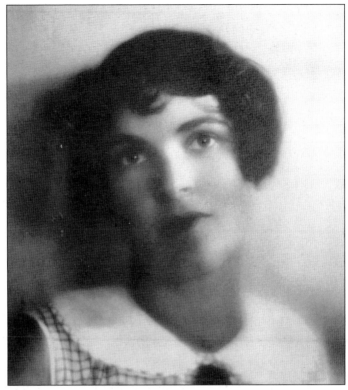

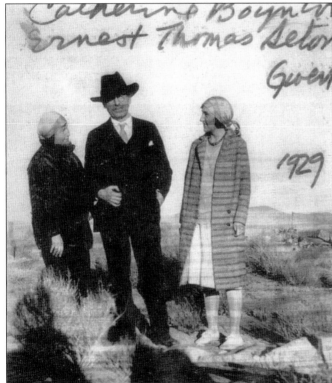

Catherine Boynton (left); Ernest Thomas Seton, (center), who founded the Boy Scouts of America; and Gwen stand on Rancho Yucca Loma property. Seton arrived at the rancho in 1918 and was a world-famous writer and artist. He designed a great deal of the artwork at Rancho Yucca Loma. (Courtesy Victor Valley College.)

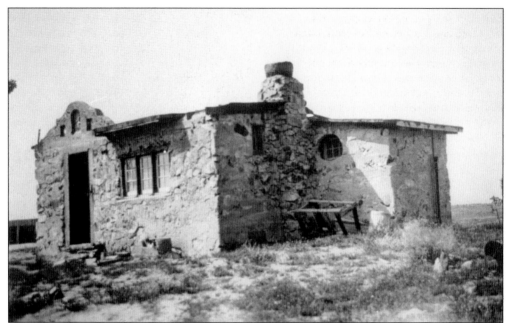

For the first year, Rancho Yucca Loma was occupied by Gwennie Boynton and Mildred Strong. For many months, the two girls camped in tents, showered and laundered in Victorville, and built the original homestead they named "The Arc." Boynton and many of Rancho Yucca Loma's early supporters traveled from Los Angeles on the weekends to help build the original house. (Courtesy Victor Valley College.)

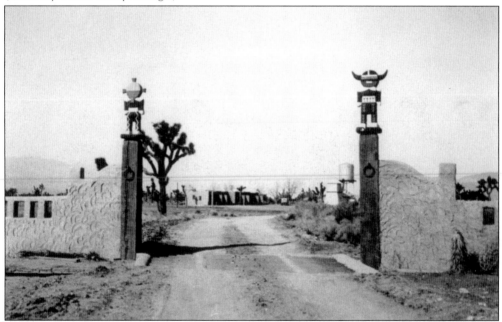

Seton's large kachina statues greeted guests as they entered the ranch. Rancho Yucca Loma comprised 19 buildings during its heyday. It had a main house as well as large and small adobes. The main house had a kitchen, living room, dining room, and two bedrooms. (Courtesy Victor Valley College.)

From left to right are Nina Barry, Billy Boynton, and Catherine Boynton. Nina was one of Catherine's good friends and visited Rancho Yucca Loma frequently. Her son John moved to Rancho Yucca Loma permanently because of health problems. Billy became a high-level politician in the Midwest. (Courtesy Victor Valley College.)

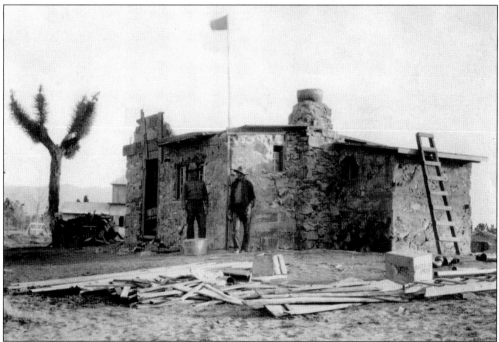

In 1921, Ernest Thomas Seton (left) built a home on Rancho Yucca Loma out of stones and with the help of 12-year-old John Barry, right. Seton used his home for Boy Scout campouts and council meetings. (Courtesy Victor Valley College.)

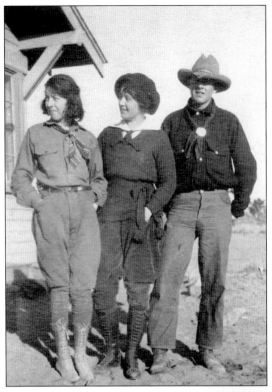

From left to right are Kitty, Nina, and John Barry. John and his sister Kitty were sent to Rancho Yucca Loma after they both suffered from influenza, which they caught during an outbreak in their hometown of Greenwich, Connecticut. Though John spent most of his adult life in the High Desert, Kitty made her home in Glendale, California. (Courtesy Victor Valley College.)

From left to right are Gwennie, Billy, and Catherine Boynton. The early efforts of the Boyntons and their friends quickly made Rancho Yucca Loma a sought-after health ranch. (Courtesy Victor Valley College.)

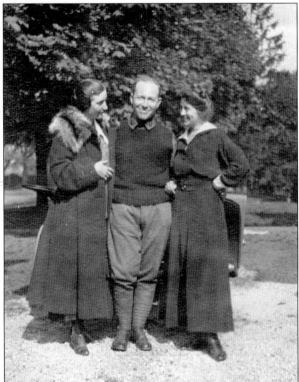

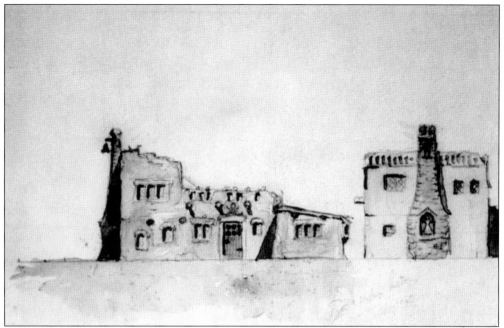

Sketches of Ernest Thomas Seton's home were preserved for future generations, thanks to the early settlers who marked Rancho Yucca Loma's existence. Mildred Strong Rivers's daughter Ann authored *Rancho Yucca Loma*, a narrative history of the famous visitors and happy lifestyle at the ranch. (Courtesy Victor Valley College.)

Life for Rancho Yucca Loma residents was active and inspiring. Everyday chores accompanied a lifestyle of artistic freedom. Ernest Thomas Seton (center) poses for the camera with an ax in his hand. (Courtesy Victor Valley College.)

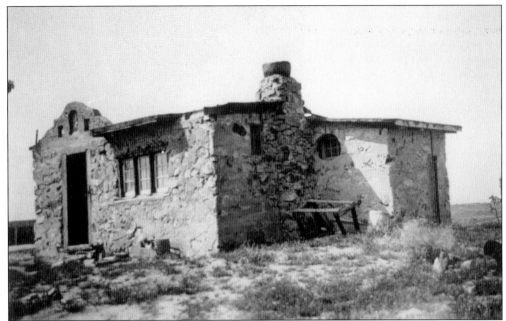

Ernest Thomas Seton's home became John Barry's childhood haunt. Barry always walked to school, while his classmates rode horses or farm buggies. He was sometimes the only student in class, as other kids were often called home to harvest crops. Barry said he was not sent to Apple Valley to farm but was sent there to heal. (Courtesy Victor Valley College.)

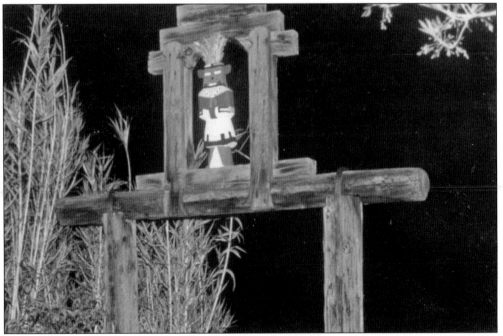

Boynton's ties to the Los Angeles basin paid off as a steady flow of wealthy visitors searched for healing at Rancho Yucca Loma. Many enthusiastic patrons, such as movie star David Manners, moved to the property permanently. This photograph shows one of Seton's art structures. (Courtesy Victor Valley College.)

Automobiles sitting behind one of Ernest Thomas Seton's statuesque art pieces show that Rancho Yucca Loma was popular for decades after its creation. (Courtesy Victor Valley College.)

According to Ann Rivers Sudrow, who grew up at Rancho Yucca Loma, the big adobe had a bedroom and bathroom on each end of the structure with a recreation room connecting them. A large fireplace had seating in front of it, and the structure was constructed from sticky mud bricks. (Courtesy Victor Valley College.)

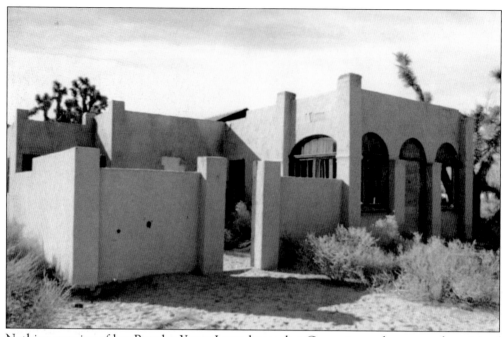

Nothing remains of her Rancho Yucca Loma home, but Gwennie was known as the spirit of Rancho Yucca Loma and is said to have comforted Hollywood superstar Clark Gable when he arrived at Rancho Yucca Loma to grieve for his wife, Carol Lombard, who was killed in an airplane crash. (Courtesy Victor Valley College.)

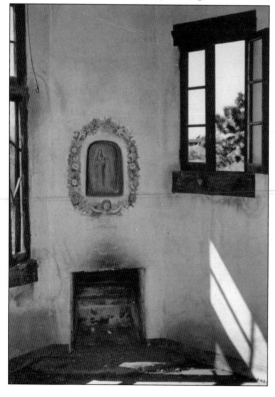

A cozy fireplace was located inside Gwennie's cabin—her heating system for cold winter nights. (Courtesy Victor Valley College.)

Today this tiny adobe house, which is still standing at Rancho Yucca Loma, is all that remains of the home of actor David Manners. Built by the actor in the 1920s, it is believed to be the oldest home still standing in Apple Valley. (Courtesy Victor Valley College.)

This photograph of the pueblo shows the Southwest-style building's large picture window. The pueblo was made up of four rooms connected with pine beams. A workshop was made up of a workroom with waist-high work benches. (Courtesy Victor Valley College.)

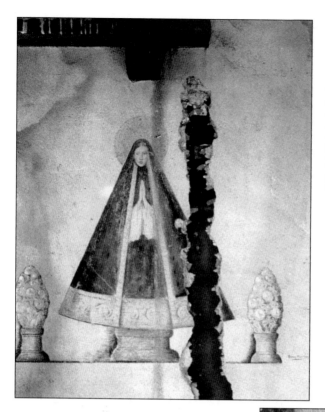

The now-famous Mexican painter Ramos Martinez was impoverished and living in Mexico when he learned that his young daughter, who was born without kneecaps, would need expensive surgery to live a normal life. After praying to Mexico's patron saint, Our Lady of Guadalupe, Martinez traveled to Los Angeles to make money for his daughter's medical care. (Courtesy Victor Valley College.)

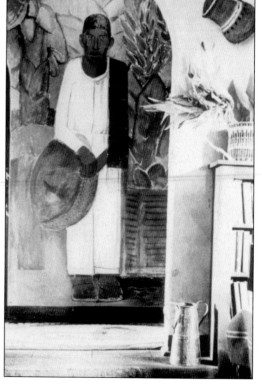

When Catherine and Gwennie learned of Martinez's plight, they helped secure money for the child's surgery and invited Martinez and his daughter to Rancho Yucca Loma to recover. Martinez was so appreciative of the women's hospitality, that during his year-long stay he painted several murals on Rancho Yucca Loma's walls. This mural features a man Gwennie named "Pacho." (Courtesy Victor Valley College.)

Martinez painted an Aztec man and woman in the Ranch House living room and a Madonna and child as a tribute to the answered prayer God gave through the Boyntons. (Courtesy Victor Valley College.)

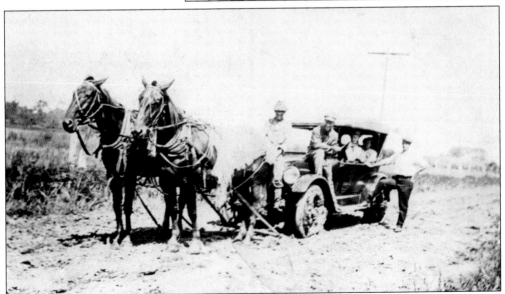

Life at Rancho Yucca Loma continued to grow. Traveling on horses soon took a back seat to driving cars. It appears that at the time of this photograph, though, the horse was a more reliable way to travel. (Courtesy Victor Valley College.)

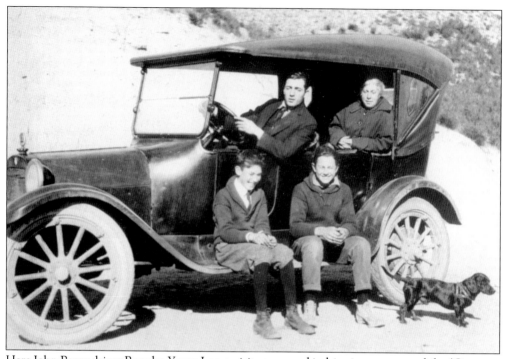

Here John Barry drives Rancho Yucca Loma visitors around in his vintage automobile. (Courtesy Victor Valley College.)

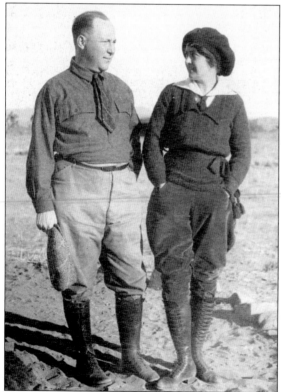

Nina Barry, who lived primarily in the Los Angeles area, visited her children at Rancho Yucca Loma regularly. This early photograph shows a young Nina with Billy Boynton. (Courtesy Victor Valley College.)

The Rancho Yucca Loma swimming pool provided welcome relief during sweltering summer afternoons. (Courtesy Victor Valley College.)

Boynton mixed a variety of plants when creating Rancho Yucca Loma but still had plenty of wild foliage to tame. The man in this photograph is unidentified. (Courtesy Victor Valley College.)

After a prestigious college career at Stanford University, John Barry returned to Apple Valley after a conversation with friend William Randolph Hearst, who told him to invest in a newspaper in an area where he would like to stay. After a stint as a *San Bernardino Sun* correspondent, Barry, his mother, and another partner bought the *Victor Press*, which later became the *Daily Press*, the High Desert's largest daily newspaper. This photograph shows Nina, a silent partner in the paper. (Courtesy Victor Valley College.)

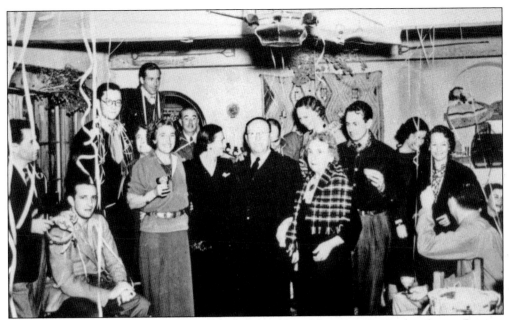

In the late 1930s, Rancho Yucca Loma was alive with celebrity guests. Such icons as Gregory Peck, writer Mary Roberts Rinehart, *New York* magazine cartoonist Tony Sarg, and Southern California oil magnate Newton Bass spent many wandering nights at the ranch. In 1940, Gwen attended New York's Julliard School of Art. She returned to Rancho Yucca Loma with her new husband, Herman Behr, for one year. With her return, she encouraged many of New York's wealthiest citizens to join her at Rancho Yucca Loma for some lengthy visits. This photograph marks a party held on December 31, 1937. (Courtesy Victor Valley College.)

When World War II broke out, Gwennie threw her efforts into serving the country and rented all Rancho Yucca Loma's rooms out to servicemen in need of housing, and she would drive soldiers back and forth to Victorville as needed. (Courtesy Victor Valley College.)

Rancho Yucca Loma fell to pieces after Catherine Boynton died in 1949. Gwennie pressed on without her beloved mother but died four years later, in 1953, of breast cancer, according to Ann Rivers Sudrow. (Courtesy Victor Valley College.)

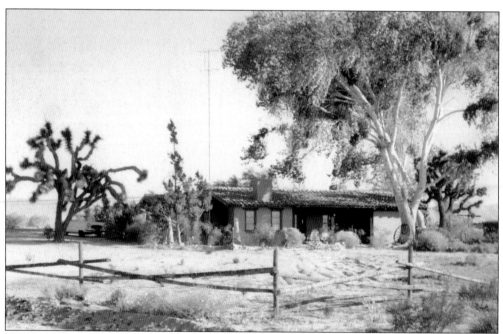

The ranch was sold to future Apple Valley land baron Newton Bass, who lived at Rancho Yucca Loma several months before it was burned to the ground. Luckily for Bass, his custom home near the future center of Apple Valley was completed by that time and was ready for him to occupy. No one was ever accused or convicted of setting the blaze. (Courtesy Victor Valley College.)

Five

BIG IDEAS

The 1940s were a visionary time for the modern fathers of the area. Newton Bass, who was looking for open real estate for a Brahma Bull ranch hobnobbed with the rich and famous socialites who frequented the many Apple Valley guest ranches. (Courtesy Victor Valley College.)

Instead of making millions on Brahma bulls, Newton Bass, the young Long Beach oil tycoon, saw a future promoting the glory of the sprawling Western lifestyle to the wealthy and influential. (Courtesy Victor Valley College.)

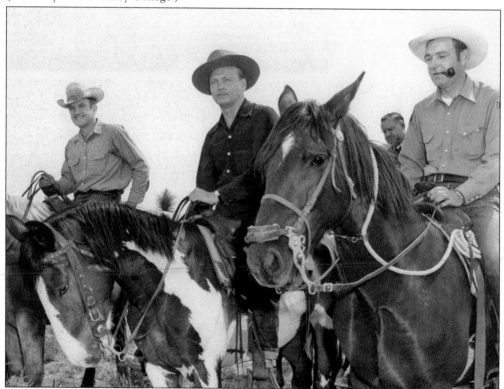

Thanks to the booms and busts that affected Apple Valley over the decades, local residents were hearty and ready to adjust to the changing market. Bass arrived in Apple Valley prepared to make a deal that would ultimately make the Old West a part of the area's future. Many stage photographs were taken to promote the Bass/Westlund empire. Though the three front horsemen are unidentified, Newton Bass's head is visible in the background. (Courtesy Victor Valley College.)

The desert was alive with hope and teeming with potential. Like the Mojave River itself, entrepreneurial ideas flowed openly and also below the surface, moving the Apple Valley into the future. (Courtesy Town of Apple Valley.)

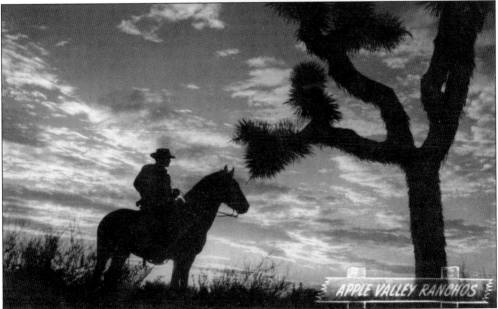

During World War II, while Bass was scouting property in Apple Valley, his partner and brother-in-law, Bud Westlund, was serving in the U.S. military. The pair was equipped with plenty of money from founding Richland Oil Company in 1939 and from Westlund's father's role as the majority partner in the J. C. Penney Company. This early Apple Valley Ranchos postcard was used to spark interest in the property during and after the war. (Courtesy Victor Valley College.)

Bass and Westlund communicated via mail during the war. While in Europe, Westlund agreed to the Bass purchase and arrived in the High Desert upon his return. Bass had committed to the 1945 purchase of 6,300 acres, which would soon draw hundreds of people to Apple Valley. The new Bass/Westlund property, purchased for $2.50 per acre from Southern Pacific Railroad, would become the foundation of a new empire. In this photograph, five unidentified men on horseback enjoy the quiet desert. (Courtesy Victor Valley College.)

In total, Newton Bass and Bud Westlund acquired 25,000 acres of land and laid the framework for modern-day Apple Valley. The founders generously donated several pieces of land to the Town of Apple Valley for various community-oriented projects. The pair paved many roads and brought infrastructure to the calm desert climate. (Courtesy Town of Apple Valley.)

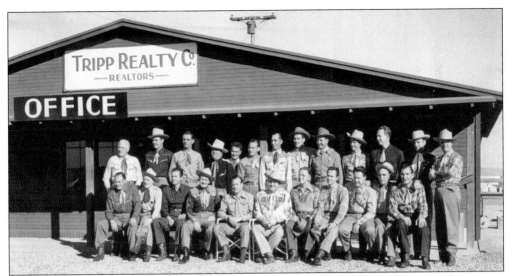

The Apple Valley Ranchos were owned, operated, and "realized" by the legendary team of Bass and Westlund, while the Tripp Realty Company served as the official brokers for the project. Though Benny Tripp headed the real estate, Bass and Westlund would often take center stage by dressing in Western garb to further illustrate their vision and inspire excitement in potential clients. (Courtesy Victor Valley College.)

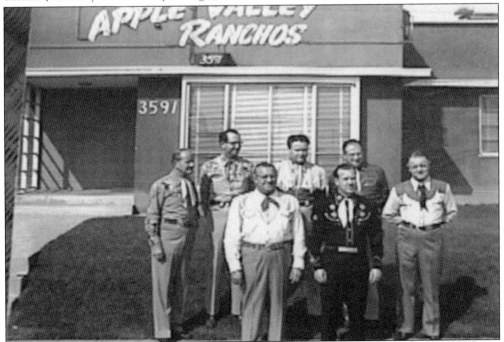

The Tripp Realty Company suffered a fatal blow when Benny Tripp died just after the Apple Valley project got going. Frank Caffray then took over for Tripp and helped build the Apple Valley Ranchos empire. Caffray, a former silent-movie star, possessed the perfect combination of natural talent and learned skills to enchant clients and encourage his own sales force. In this photograph, members of the 1947 Apple Valley Ranchos staff pose in front of one of their many offices. (Courtesy Victor Valley College.)

Ellsworth Sylvester worked as a salesman at the Apple Valley Ranchos until he was in his 90s. In its beginning, the Apple Valley Ranchos sales team worked seven days a week and excluded women from its ranks. Once again, the realization of Bass and Westlund's vision relied on the desire of Los Angeles's celebrities and businessmen to escape urban life and to live simply—with the benefit of modern conveniences. (Courtesy Victor Valley College.)

Building a new town from the ground up required tremendous effort. Salesmen were required to drive from the High Desert to Los Angeles up to three times a day. Salesmen picked up potential residents, drove them to Apple Valley, and then drove them home again. This is the Long Beach Apple Valley Ranchos office. (Courtesy Victor Valley College.)

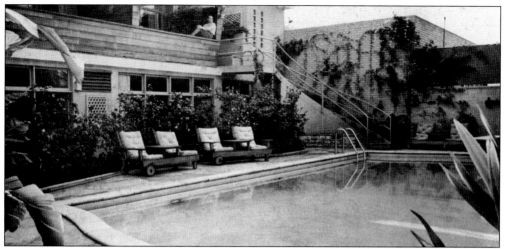

Bass and Westlund were well connected to the rich and famous in Southern California and knew how to make a good impression. This is the Beverly Hills office of the Apple Valley Ranchos. The team also had an office in Anaheim, located on Disneyland's famous Main Street, U.S.A. (Courtesy Town of Apple Valley.)

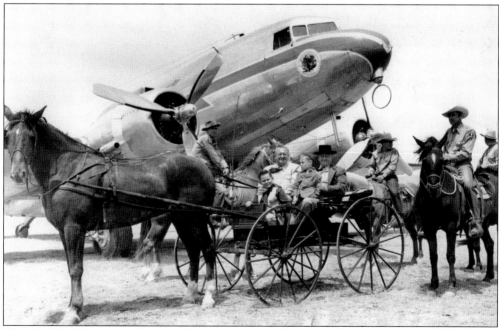

The Apple Valley Airport began its life as a small landing strip located near the corner of Wakita Road and Highway 18. More than 200 planes landed there each week, including that of Los Angeles County sheriff G. Eugene Biscaliss and his son, who was transported by Newt Bass and his son Eric (left) via the horse and buggy borrowed from the San Bernardino County Sheriff's Office. (Courtesy Victor Valley College.)

Bass saw his vision realized in 1946, when the first 15 homes were built. But a town needed more than an abundance of homes. And the Bass/Westlund team knew how to promote the lifestyle. Soon crowds were swarming Apple Valley to watch or participate in one of its numerous horse-related activities. Apple Valley Ranchos was eventually renamed the Apple Valley Building and Development Company. (Courtesy Town of Apple Valley.)

During the late 1940s, driving to an Apple Valley event was popular. Horses arrived at the home of their ancestors via horse trailer instead of the old-fashioned way—walking. (Courtesy Town of Apple Valley.)

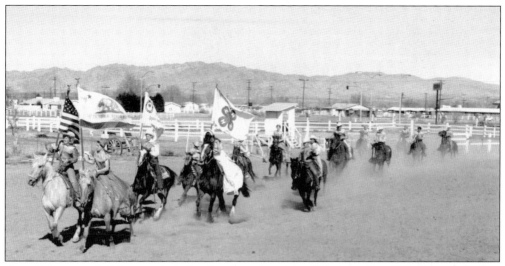

Beautiful women led the parade in local rodeos, showing off their equine skills along with their natural desert beauty. Among the more famous horse-related publicity stunts Apple Valley Ranchos arranged was a reenactment of an Old West Pony Express mail delivery, which was a delivery from San Bernardino to Apple Valley's first postmaster, Emaline Corba. The reenactment drew mass press coverage and branded the new Old West as a guaranteed success. (Courtesy Town of Apple Valley.)

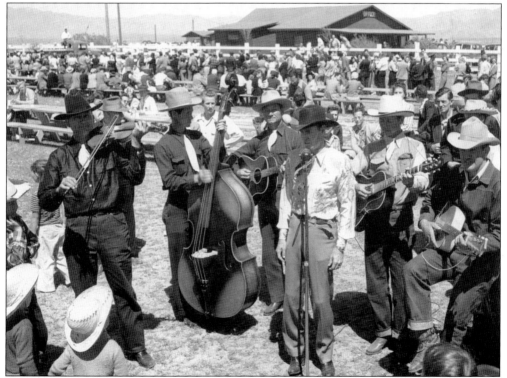

Cowboys fiddled with their horses and with musical instruments at one of the dozens of Apple Valley Ranchos events. The Apple Valley Ranchos office can be seen in the background. (Courtesy Victor Valley College.)

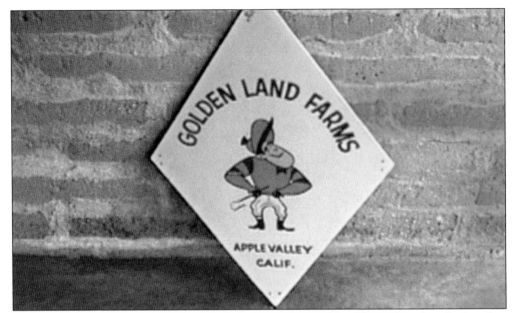

Bass and Westlund opened Golden Land Farms, a Thoroughbred horse breeding facility that would produce top-quality stock. Golden Land Farms was used to train horses as well. One horse, Apple Valley Smog, competed at Santa Anita Race Track in Southern California. (Courtesy Town of Apple Valley.)

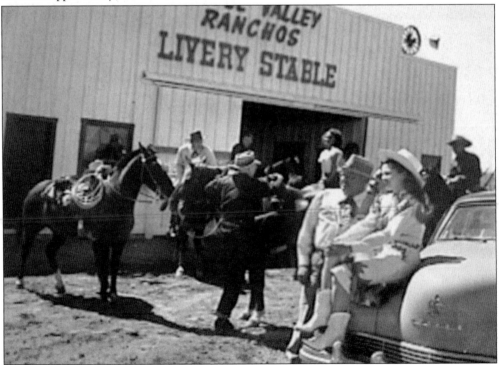

Apple Valley Ranchos livery stable served multiple purposes. Not only was it used in big events, but it was also used by Bass and Westlund to entertain the celebrity guests that flocked to Apple Valley to test out its newest attraction—the Apple Valley Inn. (Courtesy Victor Valley College.)

Six

BIG PERSONALITIES

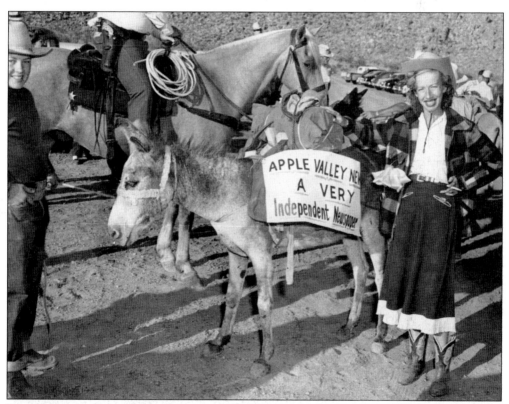

Eva Conrad, a successful San Francisco radio advertising sales veteran, moved to Apple Valley and married Lloyd Conrad, a *Los Angeles Times* reporter. The couple took over the two-year-old *Apple Valley News* in 1950. Eva said in an oral interview that she liked Apple Valley because of its family atmosphere. Eva was well known in Apple Valley as well as in the neighboring cities of Victorville and Hesperia. (Courtesy Town of Apple Valley.)

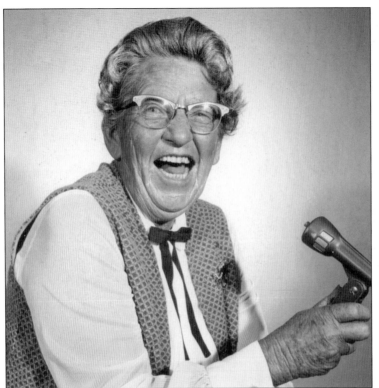

Apple Valley was home to some of the country's most avid horse lovers. In this photograph, Hattie Gibson calls a square dance. Hattie and Floyd Gibson created The Dancing Hooves, a group of horse lovers in Apple Valley who square-danced on horseback. The Dancing Hooves also performed at children's shows, rodeos, parades, and fairs. (Courtesy Town of Apple Valley.)

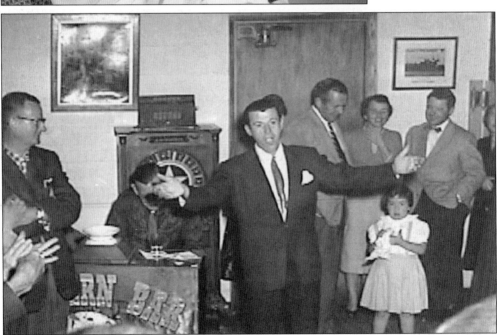

The Branding Iron was among the first commercial buildings erected in Apple Valley during the Bass/Westlund era. It served a variety of purposes, including being a night spot and a church. The Branding Iron looked like a barn, complete with horses tied to a hitching post. This photograph was taken during a 1948 dance. (Courtesy Town of Apple Valley.)

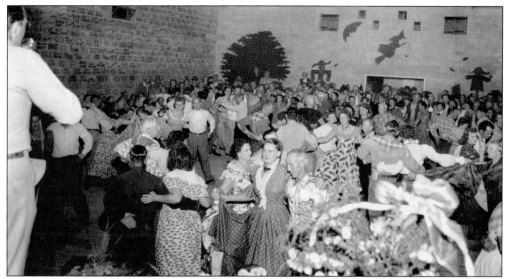

This Halloween Dance appears to have been held at the Apple Valley Community Center, which was built brick by brick in the 1950s, both being paid for and built by the community itself. (Courtesy Town of Apple Valley.)

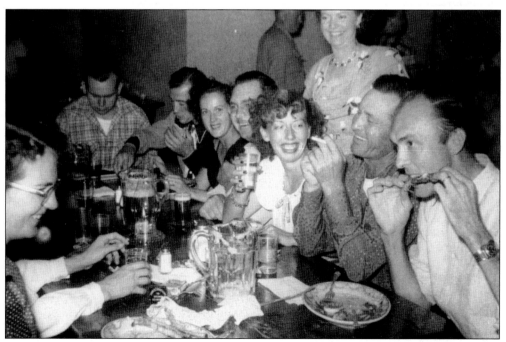

Eva Conrad (center, smiling) shared laughter with community members at one of the area's many community events. Dances were nothing new to Apple Valley, however, as people had been gathering there since the early 1900s to enjoy one other, food, and dancing. (Courtesy Town of Apple Valley.)

Eva's newspaper captured a variety of community interactions. This curious group shot is overpowered by what appears to be a couch in the foreground. (Courtesy Town of Apple Valley.)

A healthy amount of beer sits on the table in front of these happy Apple Valley visitors and residents. This photograph is not dated but looks as though it was taken in the early to mid-1950s. (Courtesy Town of Apple Valley.)

Whatever it is that amuses these three men was worthy of a newspaper photograph, which was taken outside one of Apple Valley's family restaurants built in the 1950s. It's possible that these men had some connection with the Apple Valley Chamber of Commerce. The chamber incorporated in June 1948 as the Apple Valley Ranchos Businessmen's Association and changed its name to the Apple Valley Chamber of Commerce in 1952. Annual dues were $5. (Courtesy Town of Apple Valley.)

Bud Conrad stands armed and ready to shoot a photograph at a local gathering. Not only did Bud and Eva enjoy a long, happy marriage, but they also ran the paper for more than 30 years, eventually selling it in 1985. Eva, who could not give up the excitement of working at a newspaper, continued to write a weekly column in the town's subsequent paper, the *Apple Valley Leader*. (Courtesy Town of Apple Valley.)

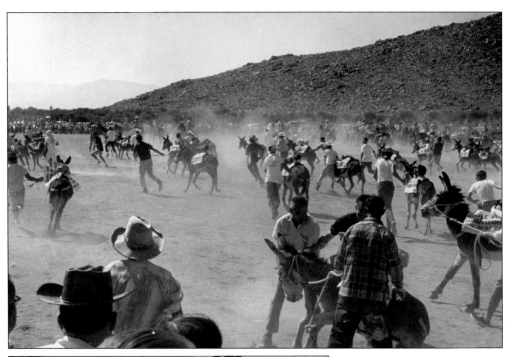

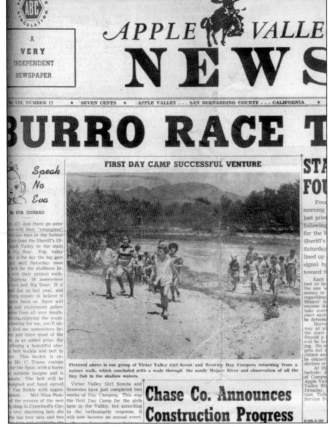

Apple Valley thrived on community interaction. Annual burro races were widely attended. The *Apple Valley News* article below celebrated the annual event. In an oral interview, early Apple Valley resident Gertie Bowen described the burro races as an appropriate way to let out a little laughter and learn how to motivate the most stubborn of animals. (Courtesy Town of Apple Valley.)

Seven

MASTER MARKETING

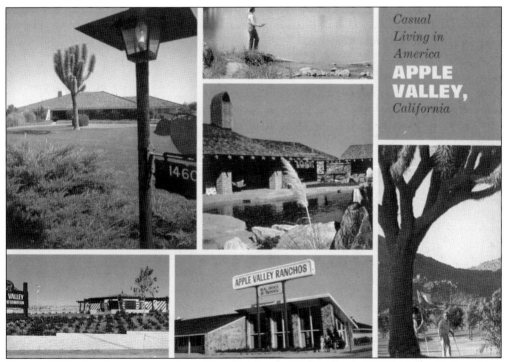

Bass and Westlund spent more than $1 million annually on Apple Valley–related advertising between the 1940s and 1960s, helping to generate regular stories in such newspapers as the *Los Angeles Times*, the *Los Angeles Examiner*, and the *San Bernardino County Sun*. (Courtesy Town of Apple Valley.)

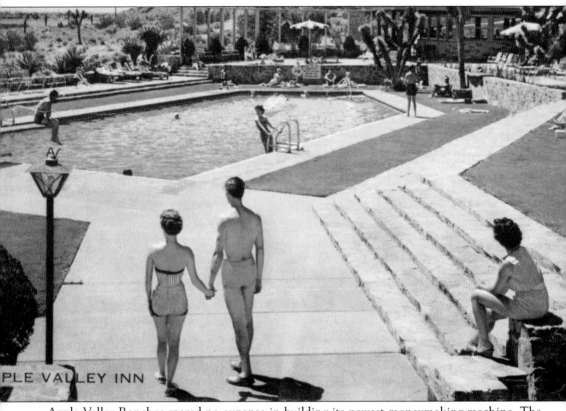

Apple Valley Ranchos spared no expense in building its newest moneymaking machine. The Apple Valley Inn was laid out in a single-story, ranch-style complex and covered 28 acres of land. The inn offered a high class, Western-lifestyle environment. The original complex included a hotel, restaurant, and social hall. The Apple Valley Inn featured the very best Western cuisine, authentic old-fashioned hay rides, and horseback riding. Guests could swim, play tennis, or golf. (Courtesy Town of Apple Valley.)

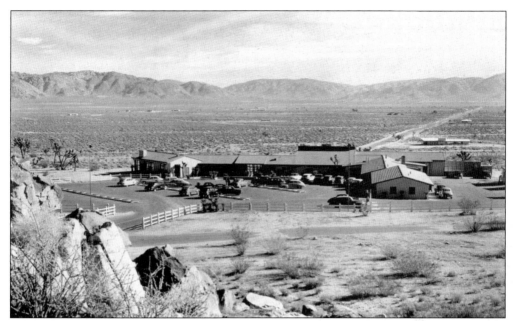

The Apple Valley Inn opened on Thanksgiving Day 1948 with a main lodge, dining room, top-of-the-line restaurant, bar, and 36 guest rooms—all housed in several separate buildings. Because telephone service was not yet available at the outlying cottages, homing pigeons were used to transport requests and communication to the inn's main lodge. Carrier pigeons were on call outside cottage doors. When they were no longer needed, the pigeons were sold to a breeder overseas. (Courtesy Town of Apple Valley.)

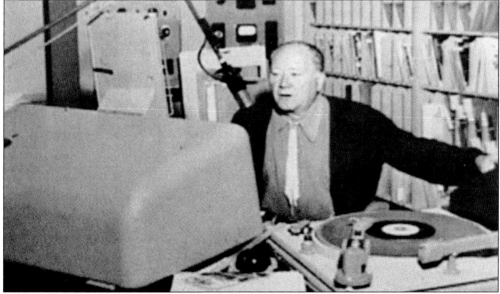

Famous in his time for his dreamy baritone voice, John Charles Thomas made his radio premiere in 1954 on KVAR, which was broadcast from its studio on inn property. Thomas and his wife, Dorothy, were among Apple Valley's famous residents. Thomas joined disc jockey Glenn Darin. In 1975, Skip Young, famous for his role as the happy-hearted neighbor on the *Ozzie and Harriet* television show, took over the KAVR microphone. (Courtesy Town of Apple Valley.)

This professional photograph of the Apple Valley Inn lobby was one of many tools Apple Valley Ranchos salesmen used to attract potential residents to the area. Apple Valley Ranchos was known to use the inn as complimentary lodging. (Courtesy Town of Apple Valley.)

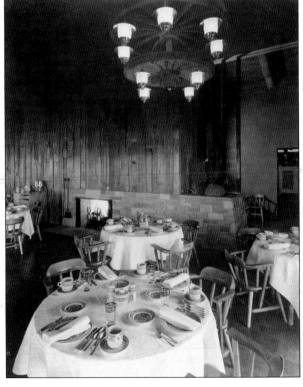

This photograph captures the atmosphere—both cozy and formal—of one of the Apple Valley Inn dining rooms. Guests were treated to outstanding home-style cooking and a fire at dinnertime. The Apple Valley Inn built the Blossom Room, a second dining hall, and bar in its second phase. In 1952, an additional 24 rooms were built, and 41 more rooms were added in 1954. (Courtesy Town of Apple Valley.)

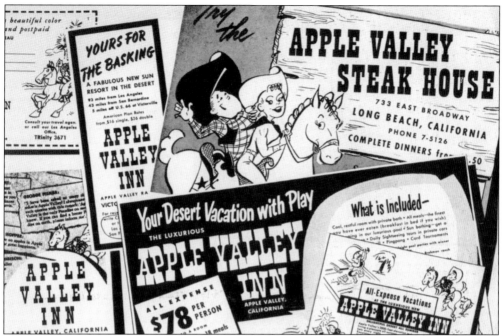

In true Hollywood fashion, the Beverly Hills publicity team of Mulle and Breen wound up falling in love with Apple Valley through their marketing efforts and moved to the area as permanent residents. Newton Bass's personality and popularity made his image in cartoon form perfect for Apple Valley's logo. The Bass cartoon was used on a variety of Apple Valley publicity items. (Courtesy Victor Valley College.)

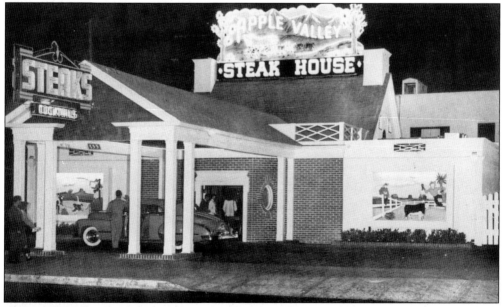

The Apple Valley Steak House was a wonderful steak-and-potato restaurant in Long Beach. Patrons would dine at the restaurant and learn all about the Apple Valley Ranchos vision of a slower pace of life and about the opportunities that awaited the adventurous people who moved there. (Courtesy Victor Valley College.)

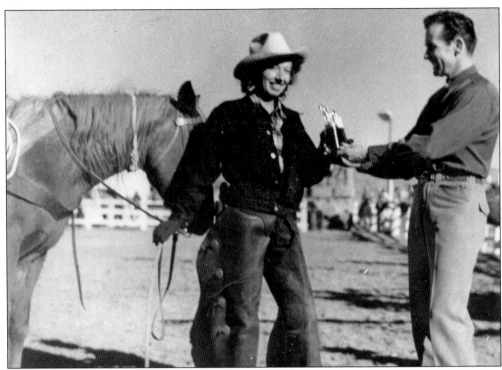

While Apple Valley Ranchos mixed the fast life of Hollywood with the idea of the Old West, those who loved the equestrian lifestyle acted as the real backbone for the future town. Eva Conrad, pictured above and below, was a talented and award-winning equestrienne. (Courtesy Town of Apple Valley.)

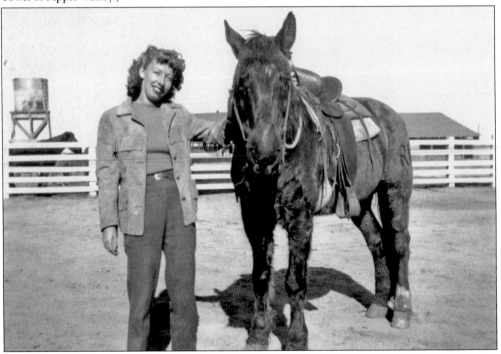

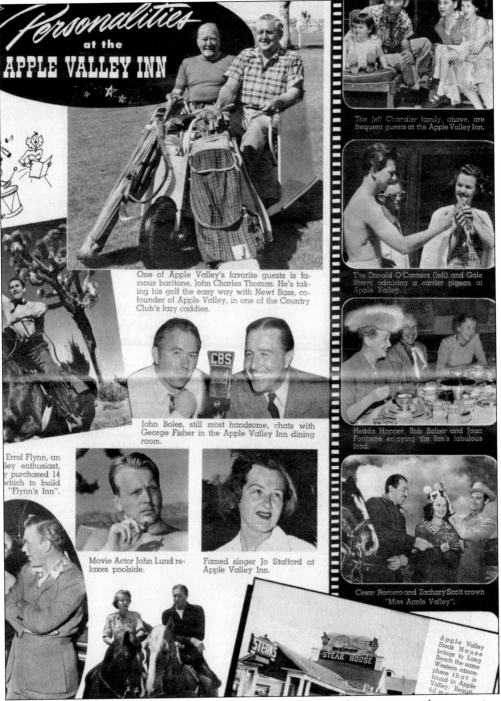

Personalities at the APPLE VALLEY INN

The Jeff Chandler family, above, are frequent guests at the Apple Valley Inn.

One of Apple Valley's favorite guests is famous baritone, John Charles Thomas. He's taking his golf the easy way with Newt Bass, co-founder of Apple Valley, in one of the Country Club's lazy caddies.

The Donald O'Connors (left) and Gale Storm admiring a carrier pigeon at Apple Valley.

John Boles, still most handsome, chats with George Fisher in the Apple Valley Inn dining room.

Hedda Hopper, Bob Balzer and Joan Fontaine enjoying the Inn's fabulous food.

Errol Flynn, an ...ley enthusiast, ...y purchased 14 which to build "Flynn's Inn".

Movie Actor John Lund relaxes poolside.

Famed singer Jo Stafford at Apple Valley Inn.

Cesar Romero and Zachary Scott crown "Miss Apple Valley".

Apple Valley Steak House brings to Long Beach the same Western atmosphere that is found in Apple Valley. Beauti...ful...

While Westlund was known as a brilliant businessman, Bass was known as a marketing genius. Bass oversaw a large collection of magazine-style inserts he ran in big Los Angeles newspapers. This insert was published in the *Los Angeles Examiner*. (Courtesy Victor Valley College.)

81

THE

Golden Land

of

APPLE VALLEY

CALIFORNIA

This shot was used as a *Los Angeles Examiner* promotional magazine cover. It highlights the Western theme that became the trademark of Apple Valley. Though Apple Valley did not officially incorporate until 1984, Apple Valley Ranchos set the tone the town's future residents would come to know. (Courtesy Victor Valley College.)

This promotional shot was carefully selected for its beauty. Snowcapped mountains in the background contrast with the jagged Joshua tree–dotted desert in the foreground.

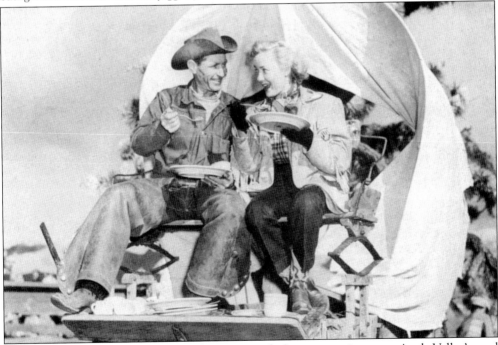

Bass and Westlund used chuckwagon dinners served after wagon trips across Apple Valley's rural landscape as another opportunity to entice future residents. Old-style "Cowboy and Indian" fights were also staged along the wagon trail. (Courtesy Town of Apple Valley.)

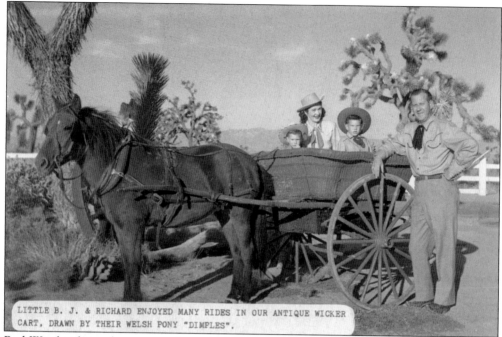

LITTLE B. J. & RICHARD ENJOYED MANY RIDES IN OUR ANTIQUE WICKER CART, DRAWN BY THEIR WELSH PONY "DIMPLES".

Bud Westlund stands next to a horse and buggy with his wife, Dorothy, and his sons. The photograph was used for publicity, and the wicker basket is said to have been an antique. The horse and buggy belonged to the Westlund family. (Courtesy Town of Apple Valley.)

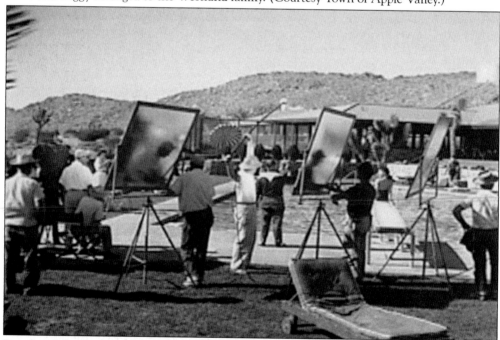

Bass found that he could further promote Apple Valley through the television and movie industry. This shoot is taking place at the Apple Valley Inn. The inn was highlighted in 1965 by director John Myhers, who shot most of the movie scenes for *Saturday Night in Apple Valley* (a.k.a *Saturday Night Bath in Apple Valley*) there. (Courtesy Town of Apple Valley.)

84

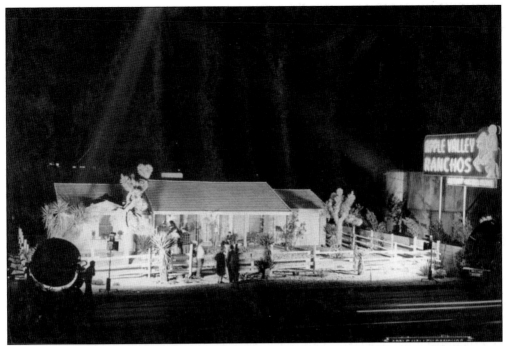

This shot of Bass orchestrating a photo shoot at night at the Apple Valley Ranchos illustrates the lengths Apple Valley Ranchos was willing to go to get their vision of Apple Valley just right. (Courtesy Town of Apple Valley.)

"APPLE VALLEY?... RIGHT STRAIGHT AHEAD A FEW MILES!"

Further promotion of Apple Valley was achieved through a wide-reaching postcard campaign highlighting the area. Potential residents were treated to images of a mass exodus from the Los Angeles basin to the desert. (Courtesy Town of Apple Valley.)

An undeniably important piece of the Apple Valley Inn was its lavish golf course. The course and country club were built on land donated by Apple Valley Ranchos and were designed by Bill Bell. Through the years, many golf course tournaments were played at the prestigious club. Its grounds were a frequent playground to Bob Hope, Arnold Palmer, and Billy Graham. (Courtesy Town of Apple Valley.)

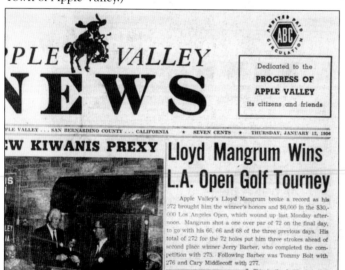

PLE VALLEY
NEWS

ABC
AUDITED PAID CIRCULATION

Dedicated to the
PROGRESS OF
APPLE VALLEY
its citizens and friends

PLE VALLEY ... SAN BERNARDINO COUNTY ... CALIFORNIA ★ SEVEN CENTS ★ THURSDAY, JANUARY 12, 1956

:W KIWANIS PREXY

Lloyd Mangrum Wins L.A. Open Golf Tourney

Apple Valley's Lloyd Mangrum broke a record as his 272 brought him the winner's honors and $6,000 in the $30,000 Los Angeles Open, which wound up last Monday afternoon. Mangrum shot a one over par of 72 on the final day, to go with his 66, 66 and 68 of the three previous days. His total of 272 for the 72 holes put him three strokes ahead of second place winner Jerry Barber, who completed the competition with 275. Following Barber was Tommy Bolt with 276 and Cary Middlecoff with 277.

Pearl Pettis Retires From Victor Valley Chamber of Commerce

Pearl Pettis (Mrs. John) officially retired January 1, 1956 as Secretary-Manager of the Victor Valley Chamber of Commerce after serving under Presidents Al Springer, Paul Kirkpatrick, John McManus, Eddie Bodeman and L. E. "Bud" Price.

Along with the growth of the community have come many problems and projects for the Chamber

This is the fourth time that Mangrum has won the L. A. Open, having walked off with top honors in 1949, 51 and 53. The last day was the big test as Mangrum had been out of tournament play for some time due to illness and injury, but a birdie on the first hole got him off to a last-day start that was prophetic of the finish. Mangrum was never seriously threatened in spite of a worrysome ninth hole at noon of the final day when he almost lost control. He hit his second shot out of bounds to the right, came back and plopped the ball into a trap,

C. of C. Annual

The first golf pro was Lloyd Mangrum. This 1956 *Apple Valley News* clipping highlights Mangrum's record-breaking win at the Los Angeles Open. Mangrum made Apple Valley his home as well as making the golf course his playground. Mangrum shot a total 272 at the 1956 Los Angeles Open. (Courtesy Town of Apple Valley.)

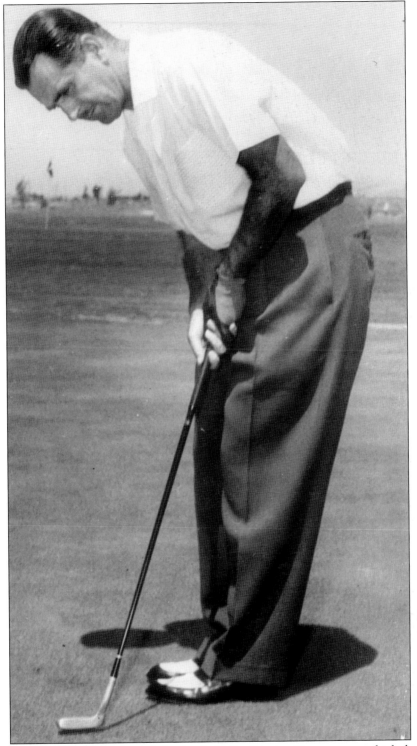

Lloyd Mangrum (pictured) organized the Apple Valley Pro Am Tournament, which drew many of Hollywood's most avid golfers and golf fans. (Courtesy Town of Apple Valley.)

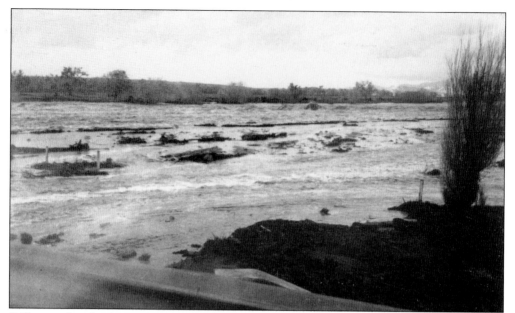

Still a novelty, this heavy winter rain filled up the Mojave River in Apple Valley. After leaving Apple Valley, the Mojave River runs to Baker, California. (Courtesy Town of Apple Valley.)

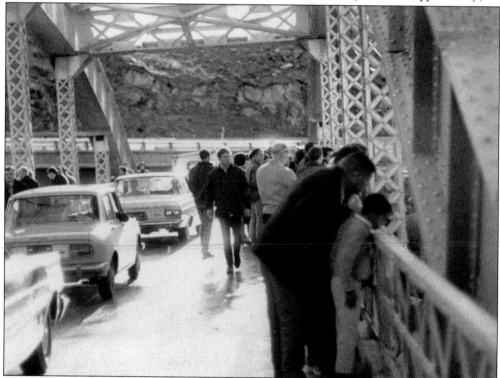

This 1960s photograph shows dozens of residents who showed up to watch the rare sight of water crossing under a nearby Victorville bridge. The desert's strange weather still attracted dozens of residents. Seeing the Mojave River run aboveground was truly a once-in-a-while event. (Courtesy Town of Apple Valley.)

Eight

MEDIA CIRCUS

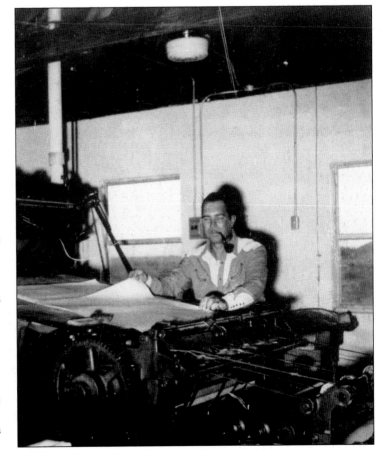

This vintage photograph of Lloyd Conrad hard at work on his newspaper press is a priceless way to illustrate how laborious the print industry was at one time. Early resident Margaret Mendel, who arrived in Apple Valley in 1947, owned Golden Land Printing, the desert's largest print shop. Mendel's husband, Al, could handset type on an old Heidelberg press he inherited from his father. (Courtesy Town of Apple Valley.)

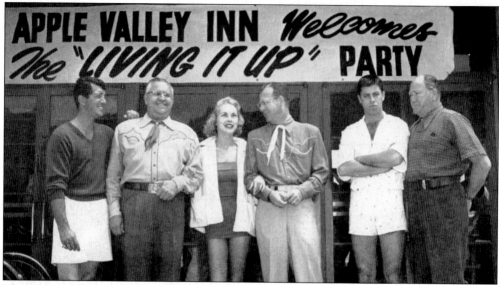

This photograph appeared in one of Bass's many magazine-style publications. Apple Valley Inn frequenters included John Wayne, Bob Hope, Phyllis Diller, Dale Robertson, Dean Martin, Jerry Lewis, Janet Leigh, Tony Curtis, June Allison, Dick Powell, Ann Blyth, Gale Storm, Robert Wagner, Natalie Wood, Gregory Peck, James Arness, Douglas Kennedy, Phil Harris and his wife, Alice Faye, Gene Autry, Billy Graham, Hedda Hopper, Lovella Parsons, Lawrence Welk, Errol Flynn, Audie Murphy, and Jonathan Winters. Pictured from left to right are Dean Martin, Bud Newton, unidentified, B. J. Westlund, Jerry Lewis, and John Charles Thomas. (Courtesy Victor Valley College.)

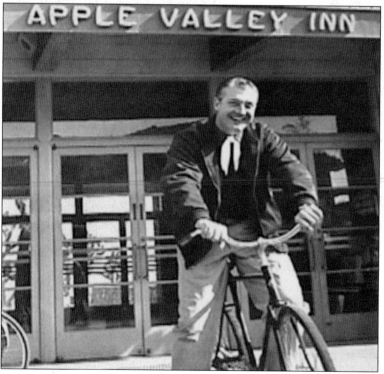

One of the Apple Valley Inn's early enthusiasts was George Reeves, television's Superman. Reeves, along with his many Hollywood friends, would glamorize Apple Valley for future generations. In 1961, Richard Nixon stayed at the Apple Valley Inn and finished the sixth chapter of his book *Six Crises*. (Courtesy Town of Apple Valley.)

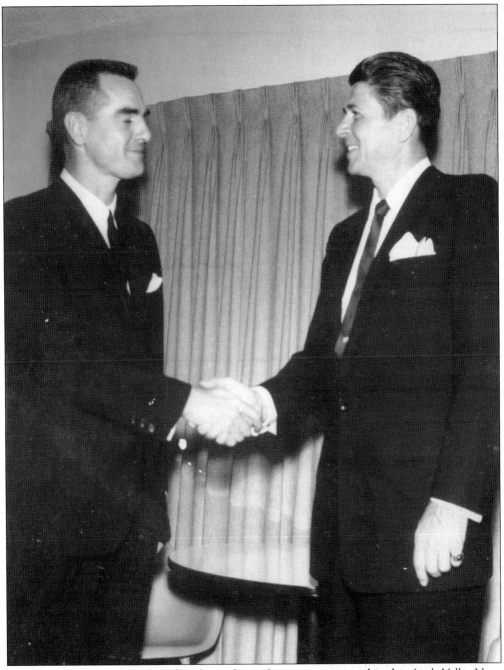

Ronald Reagan visited Apple Valley during his early years, as captured in this *Apple Valley News* photograph. (Courtesy Town of Apple Valley.)

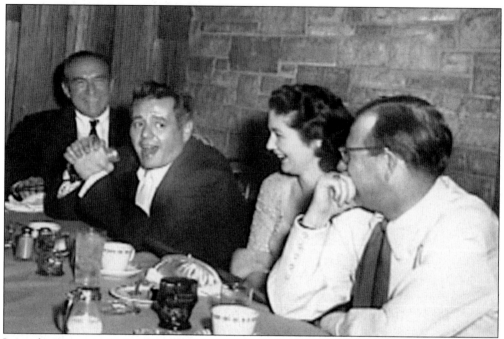

Legendary singer and comedian Desi Arnaz enjoys a laugh with guests at the Apple Valley Inn. This photograph was used as a publicity tool for Apple Valley Ranchos. (Courtesy Town of Apple Valley.)

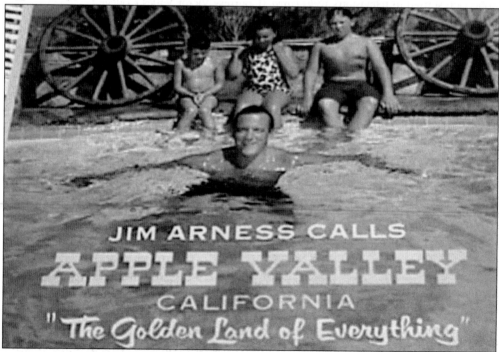

Hollywood's James Arness is featured on the cover of one of the many publicity magazines generated by Apple Valley Ranchos. As U.S. marshal Matt Dillon on television's *Gunsmoke*, Arness was well known during the early era of television. (Courtesy Victor Valley College.)

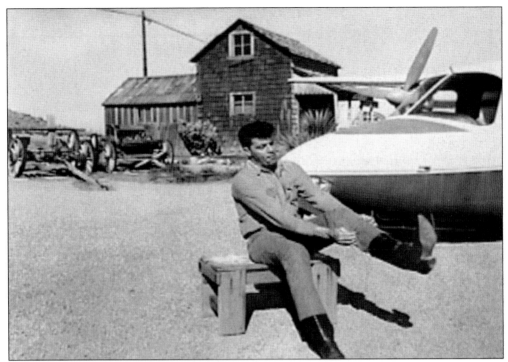

Hollywood television actor Dale Robertson is caught between the Old West and a new boot. Robertson starred in television's *Wells Fargo.* (Courtesy Victor Valley College.)

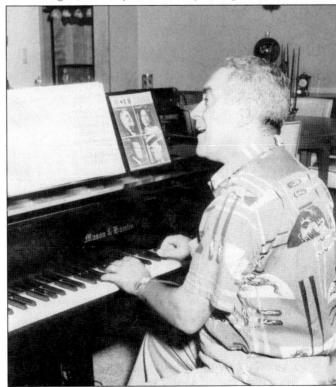

Pianist Frankie Carle liked the Apple Valley vision so much that he chose to move to the desert. Like many residents bitten by the Apple Valley Ranchos bug, Carle built a ranch-style home near one of Apple Valley's main roads. (Courtesy Town of Apple Valley.)

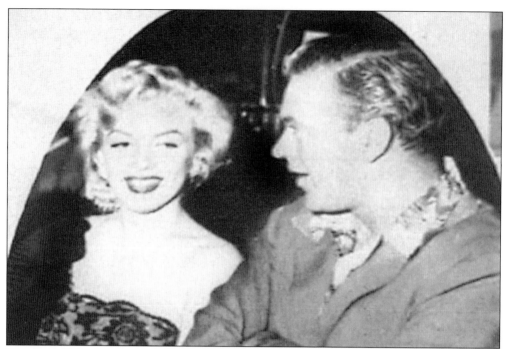

The Apple Valley Inn continued to draw celebrity guests. Here Marilyn Monroe and Frank Sinatra are featured in a special issue of an Apple Valley Ranchos publicity supplement. (Courtesy Town of Apple Valley.)

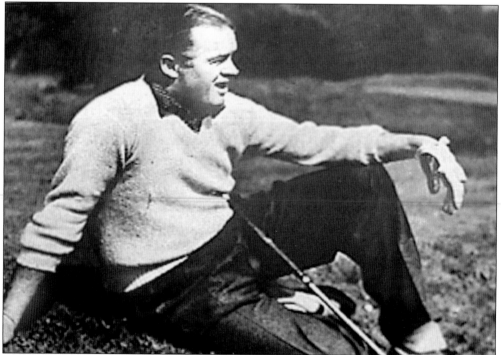

Bob Hope enjoyed the Apple Valley Inn and its golf course. Hope was known to write columns in Apple Valley Ranchos publications. (Courtesy Town of Apple Valley.)

Nine

Birth of a Town

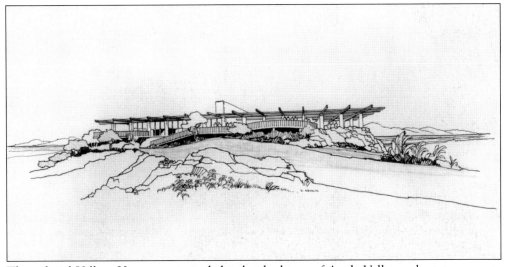

The palatial Hilltop House was intended to be the home of Apple Valley real estate magnate Newton Bass. Though Bass never resided in the home, he did store dozens of valuable collectibles within its walls. (Courtesy Town of Apple Valley.)

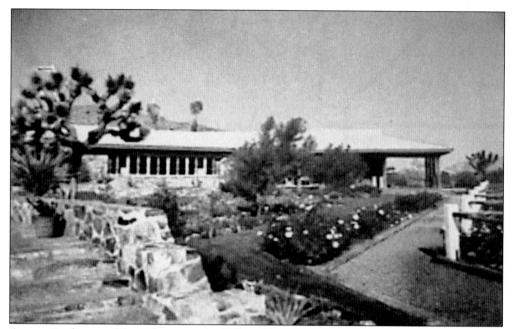

Appropriately named for its location, the Hilltop House sat atop the highest hill in Apple Valley and looked over the popular Apple Valley Inn. The Hilltop House was intended as the future home of Newton Bass but was used instead as an attractive guest home for wealthy visitors and as a museum of sorts, holding Bass's extensive collection of Hollywood memorabilia and antiques, such as Scarlett O'Hara's bed. The Hilltop House was rebuilt as a smaller structure and was used as executive offices for Apple Valley Ranchos. (Courtesy Town of Apple Valley.)

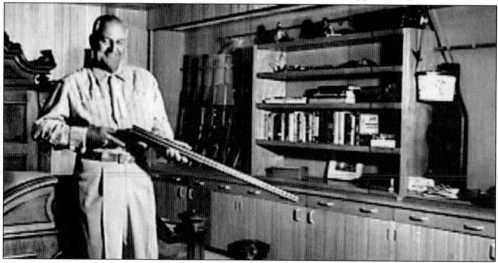

Among a variety of other valuables, Bass stored his extensive collection of guns at the Hilltop House and took publicity photographs of himself displaying his weaponry. Designed by Francisco Artigas, the Hilltop House occupied more than 7,000 square feet and featured the very latest in 1950s style and technology. The house boasted a dramatic rock formation that ushered water through its pipes and into the rock formation. The unusual formation was located in the dining room, along with part of the home's swimming pool, which existed under a large glass wall that separated the inside and outside of the house. (Courtesy Town of Apple Valley.)

In January 1967, vandals broke into the Hilltop House and set it on fire. Firefighters, called to extinguish the blaze in the wee hours of the morning, were unable to get up the steep surface of the iced-over driveway. (Courtesy Victor Valley College.)

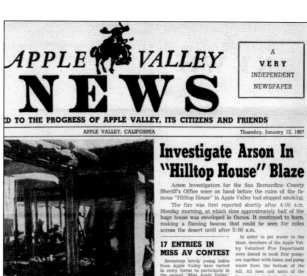

APPLE VALLEY
NEWS

A VERY INDEPENDENT NEWSPAPER

ED TO THE PROGRESS OF APPLE VALLEY, ITS CITIZENS AND FRIENDS

APPLE VALLEY, CALIFORNIA Thursday, January 12, 1967

Investigate Arson In "Hilltop House" Blaze

Arson investigators for the San Bernardino County Sheriff's Office were on hand before the ruins of the famous "Hilltop House" in Apple Valley had stopped smoking.

The fire was first reported shortly after 4:00 a.m. Monday morning, at which time approximately half of the huge house was enveloped in flames. It continued to burn, making a flaming beacon that could be seen for miles across the desert until after 5:00 a.m.

In order to get water to the blaze, members of the Apple Valley Volunteer Fire Department were forced to hook four pumpers together with hoses and pump water from the bottom of the hill. All men and units of the Department, including five pumpers and three other units responded to the call while units from Victorville stood by to cover at Apple Valley Fire Stations. The local men were under the direction of Fire Chief Robert Merrill. Icy conditions on the steep, winding road hampered the fire fighters and while no firemen were seriously injured, Terry Caldwell sustained a cut hand that required stitches and Gary Jacobs was severely chilled when he fell into the swimming pool while fighting the fire.

The "Hilltop House," built by Newton T. Bass in 1960, was a famous landmark and tourist attraction in the area. It was built by Hal B. Smith, at a reported cost of a quarter-million dollars

once dramatically beautiful front room and master bedroom is shown g on smoldering embers. The "Hilltop House" was virtually a total steel girders and devoured wood paneling in a blaze that could be os miles of desert. Accessible only from one steep winding road, the firemen could reach it. The locked gate at the bottom of the road uipment could get through.
AV Newsphoto

17 ENTRIES IN MISS AV CONTEST

Seventeen lovely young ladies from Apple Valley have turned in entry forms to participate in the annual "Miss Apple Valley" Contest to be held on Friday, February 10th in Roy Rogers' Apple Valley Inn. The event, sponsored by the Apple Valley Chamber of Commerce, will include a dinner before the contest. The price is $6.50 per person.

Those who will vie for the honor of being named Miss Apple Valley to represent this community for the year 1967 and also compete in the Orange Show Queen Contest are: Kalen Jester, Donna Stokeman, Debbie Crawford, Sharon Brugliera, Sharon McFarland, Nancy Petersen, Monica Robiczek, Gayle Tasberg, Debbie Piott, Roxana Ross, Jackie Harter, Joan Ellen Gentins, Susan Cheney, Carolyne Walton, Joane Kent, Debbie Grohs and Ruth Thompson.

GOOD LUCK DANCE ON FRIDAY THE 13th

Apple Valley Moose Lodge #1810 will start regular dances every second and fourth Friday

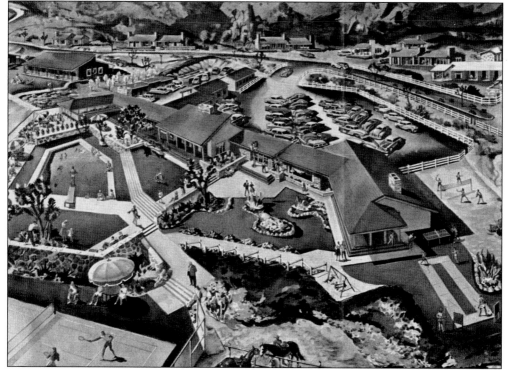

The Hilltop House overlooked this stately and dramatic landscape, highlighted by the Apple Valley Inn complex pictured above. (Courtesy Victor Valley College.)

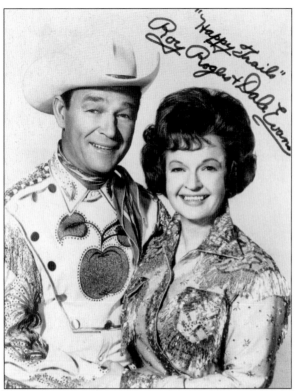

Famous duo Roy Rogers and Dale Evans were so in love with the Apple Valley mystique that they sold their Hidden Valley Ranch and relocated to Apple Valley permanently in November 1964. (Courtesy Town of Apple Valley.)

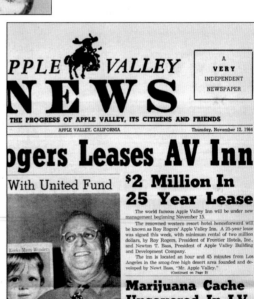

Along with their plan to open a Roy Rogers and Dale Evans museum across the street, Rogers and Evans leased the Apple Valley Inn and made the resort a permanent part of their lives. (Courtesy Town of Apple Valley.)

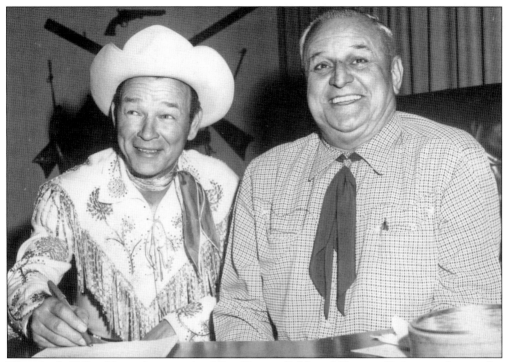

This *Apple Valley News* photograph of Roy Rogers (left) and Newton Bass was taken at the historic signing of the $2 million, 25-year lease from Apple Valley Ranchos to Roy Rogers and Dale Evans. (Courtesy Victor Valley College.)

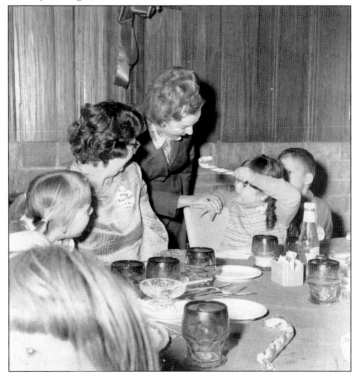

Dale Evans was popular with the residents and visitors to Apple Valley. She was heavily involved in a variety of charity events and was a frequent helping hand at St. Mary Medical Center in Apple Valley. (Courtesy Victor Valley College.)

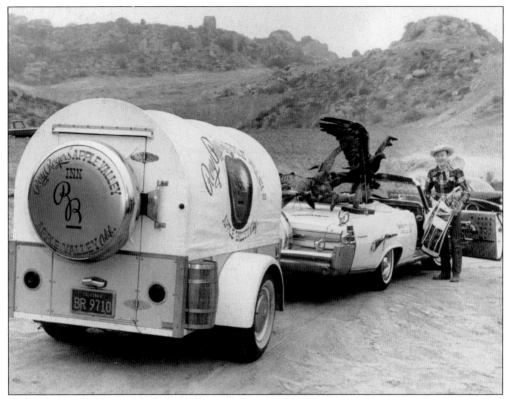

This priceless photograph of Roy Rogers and his travel trailer shows the star removing golf clubs from his car while transporting a variety of stuffed birds. The back of his trailer shows that the Apple Valley Inn was a big part of his life. (Courtesy Town of Apple Valley.)

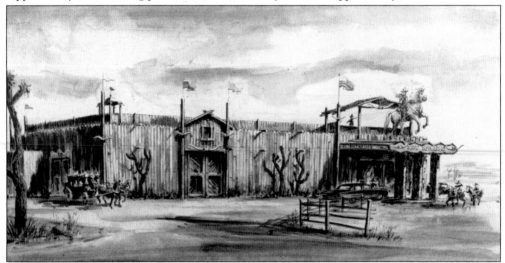

This artist's rendering of the original Roy Rogers museum is very similar to what it ultimately became. Rogers spent a great deal of effort and money collecting things he thought museum visitors would like to see. The Roy Rogers and Dale Evans Museum was eventually moved to Victorville, where it stayed for many years until it was recently relocated to Branson, Missouri. The first museum is now a bowling alley. (Courtesy Town of Apple Valley.)

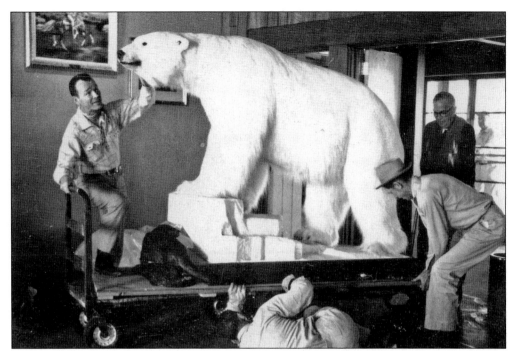

Rogers, who was an avid hunter, is seen here moving a polar bear he likely shot, into his museum. Rogers later built an arctic scene and placed a variety of items in the polar bear's company. (Courtesy Town of Apple Valley.)

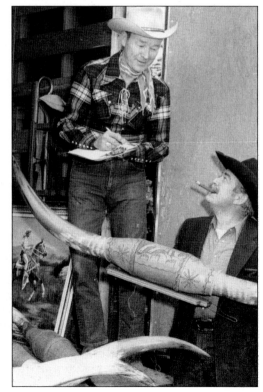

Rogers inventories some antlers, art, and a smile from a cigar-smoking friend while setting up his museum. This photograph is likely a publicity shot used to familiarize the public with his Apple Valley endeavors. (Courtesy Town of Apple Valley.)

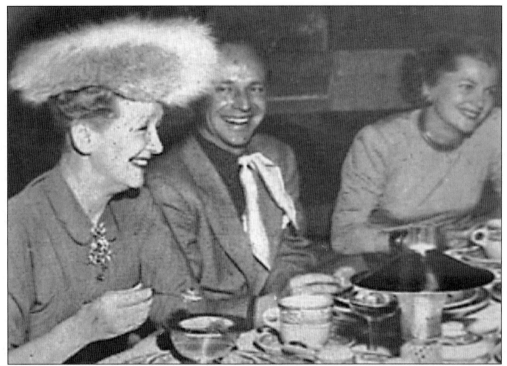

Hedda Hopper (left) was a famous Los Angeles–based gossip columnist who wrote about the Apple Valley Inn and its celebrity guests. (Courtesy Town of Apple Valley.)

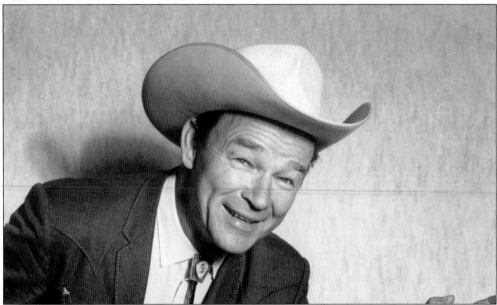

Thanks to its newest patrons, the Bass/Westlund celebrity magnet became known as the Roy Rogers Apple Valley Inn. The Apple Valley Inn finally shut its doors on May 1, 1987, as part of the Texaco Corporation's takeover. Vic's Barber Shop, located at the inn's front entrance, became the inn's longest-open business, but it closed in early 2007 so that Vic, now in his 80s, could retire. Pictured is Roy Rogers. (Courtesy Town of Apple Valley.)

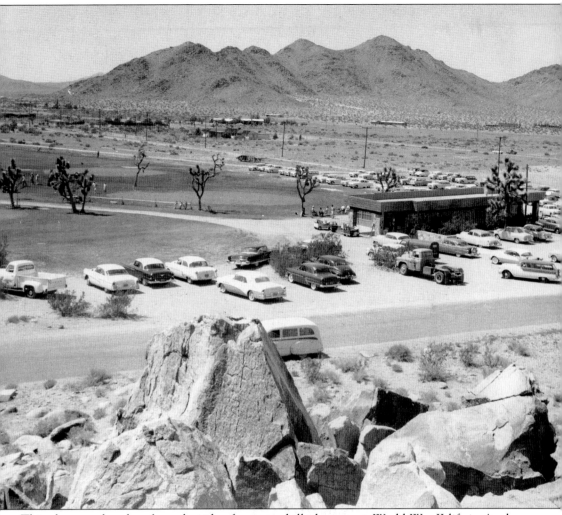

This photograph, taken from the side of a craggy hill, shows post–World War II life in Apple Valley. From the mid-1940s, Newton Bass and Bud Westlund were intent on building a city. Bass's brother Red accompanied Newt to Apple Valley because he was qualified to subdivide land and determine the mandatory land donations required to build a city. Apple Valley Ranchos eventually owned all the utilities and the Apple Valley Bank. (Courtesy Town of Apple Valley.)

The Apple Valley Ranchos Water Company activated seven wells, which were responsible for filling a 1.5 million-gallon steel reservoir and 200 miles of water mains to every one of Apple Valley's subdivided lots. Covenants, conditions, and restrictions became very important to the town as they laid the ground rules for the development of Apple Valley. These rules required mandatory bridle trails, commercial-sign height restrictions, and a minimum 25-foot home setback, thus ensuring the Bass and Westlund rural Western lifestyle that would define Apple Valley for many decades into the future. (Courtesy Town of Apple Valley.)

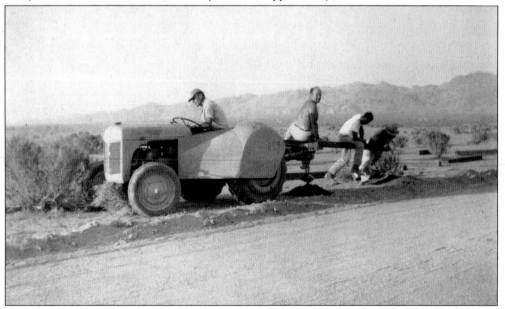

Early resident and business owner Herald Bertolotti said that in the beginning, large water pipes lay on the side of the road, and were left aboveground to show potential residents the exciting new development occurring in Apple Valley. (Courtesy Town of Apple Valley.)

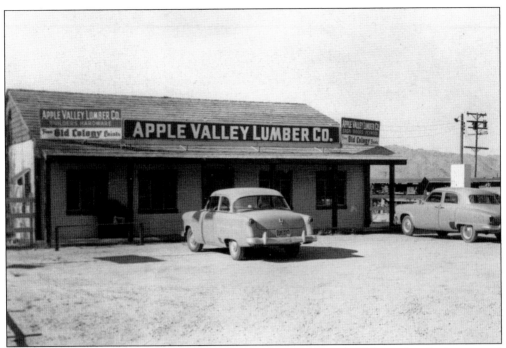

The first retail building, erected in 1946, was Valley Building and Materials, which operated out of a small, one-story structure. Valley Building and Materials was followed by Apple Valley Lumber Company in 1947. (Courtesy Town of Apple Valley.)

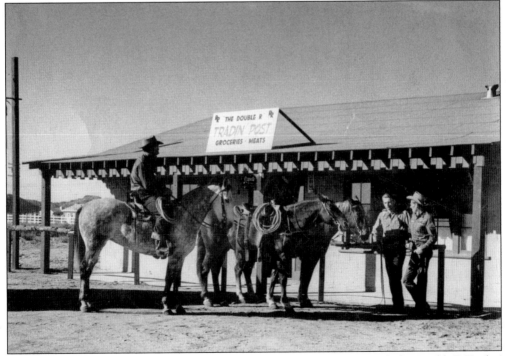

In 1947, Smittle Service Station, Crawford's Corral, Frontier Furniture, and The Double R Tradin' Post began doing business in Apple Valley. (Courtesy Town of Apple Valley.)

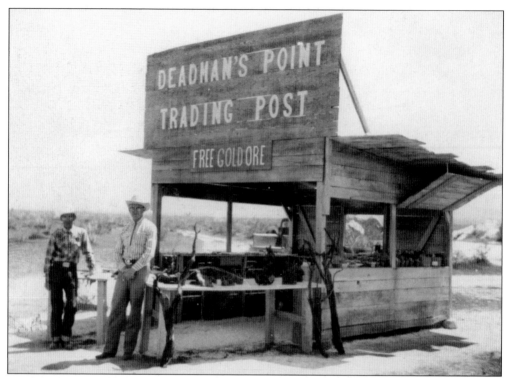

In 1948, the business community continued growing, showing the signs of a burgeoning housing market. Among the businesses that opened in 1948 was the Black Horse Motel, which featured horse stalls on motel property so equestrian lovers could explore Apple Valley on their horses. This photograph shows a makeshift trading post located at what is known as Deadman's Point, which is in one of the easternmost corners of Apple Valley. (Courtesy Town of Apple Valley.)

The El Pueblo Shopping Center, located at the east end of what was to become the first commerce center, held businesses, which included The Lazy Two, Rose's Doughnut Shop, Mary Riley's Western Wear, Children's Round-Up, W. B. Juice Bar, Arthur Shield's Insurance, Leigh's Candy Shop, El Lariato Café, and Trader Cain. (Courtesy Town of Apple Valley.)

In 1949, Long Beach business owner and real estate investor Herald Bertolotti agreed to Bass's idea to come to Apple Valley and do business. Bertolotti said that he and his wife traveled to Apple Valley Thursday of every week and handmade and laid each and every brick in 49'rs Liquor store. Construction took a year, and 49'rs Liquor opened in 1949. Bertolotti's first sale was a bottle of Old Fitzgerald Scotch, which he sold to Apple Valley Ranchos salesman George Boyer. (Courtesy Town of Apple Valley.)

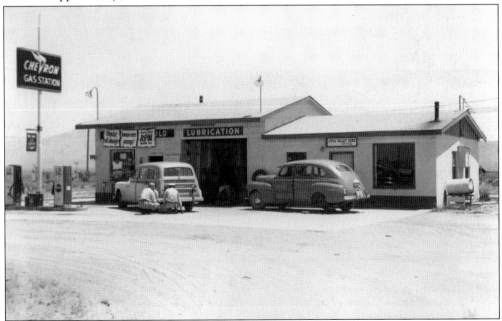

The *Apple Valley News* office was attached to a local Chevron gas station. Eventually the newspaper moved to a stand-alone building. (Courtesy Town of Apple Valley.)

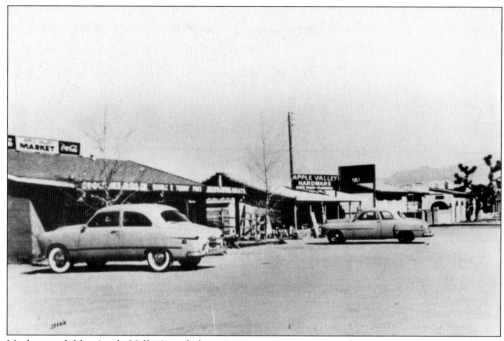

Understandably, Apple Valley's early business community was made up of companies needed by early residents. Because of all the contractors and construction crews working in the area, Apple Valley Hardware was an early success. (Courtesy Town of Apple Valley.)

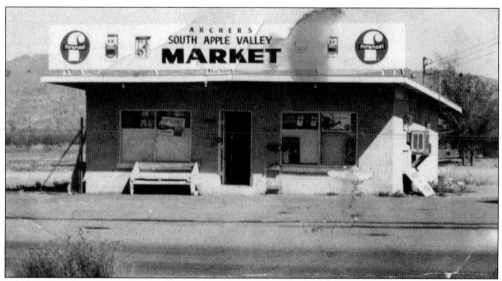

Tom Archer owned what is commonly known as a mini-market in south Apple Valley. In its heyday, however, Archer's Market was likely thought of as a bigger enterprise. (Courtesy Town of Apple Valley.)

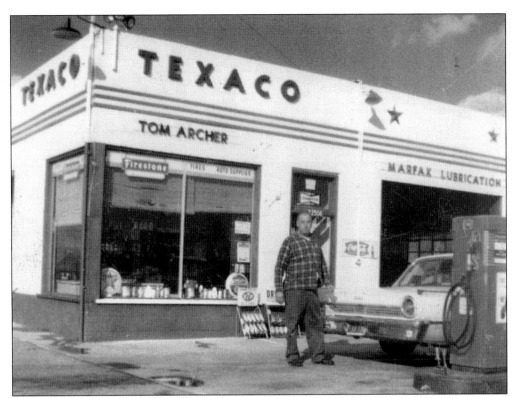

Archer also owned the local Texaco station, which was located in south Apple Valley. This 1960s photograph shows the successful business in operation. (Courtesy Town of Apple Valley.)

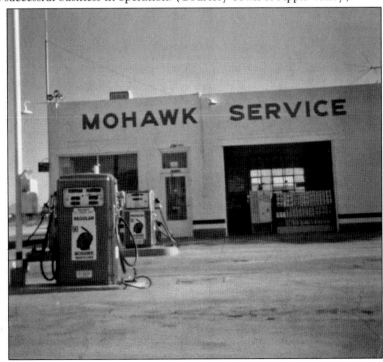

As Apple Valley grew in population and time progressed, many gas stations popped up on the horizon. The Mohawk Service Station operated successfully as well. (Courtesy Town of Apple Valley.)

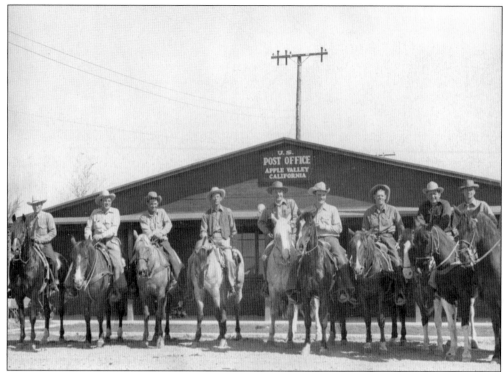

In line with the Apple Valley Ranchos way of life, the Apple Valley Post Office had a quaint, cozy feel. This *Apple Valley News* photograph was likely taken to show one of Apple Valley's sheriff's posses, which operated as a volunteer policing force in the early Apple Valley Ranchos days. (Courtesy Town of Apple Valley.)

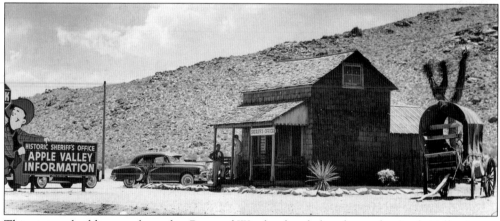

This vintage building was loaned to Bass and Westlund and placed near the Apple Valley Inn to further enhance the Western feel of the area. The building was actually Victorville's first sheriff's office and now sits next to Victorville City Hall as a reminder of its illustrious history. (Courtesy Town of Apple Valley.)

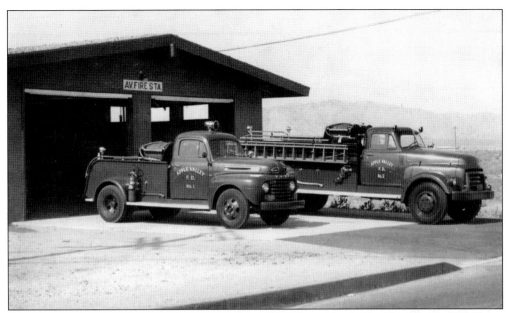

The Apple Valley Fire Department was created in 1951 and was manned by 13 volunteer firefighters. The first fire station was located at the corner of Standing Rock Road and Highway 18 in eastern Apple Valley. The land the station was located on was donated by the Apple Valley Building and Development Company, an arm of Apple Valley Ranchos. (Courtesy Town of Apple Valley.)

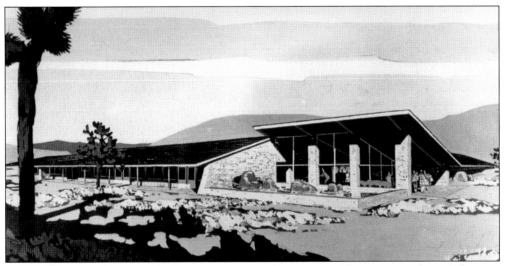

Apple Valley Ranchos continued to grow in size and reputation. This was an architect's drawing of what would be Apple Valley Ranchos' futuristic, ultramodern final office, located directly across the street from the Apple Valley Inn. But not all the buildings shown were erected on the site. (Courtesy Town of Apple Valley.)

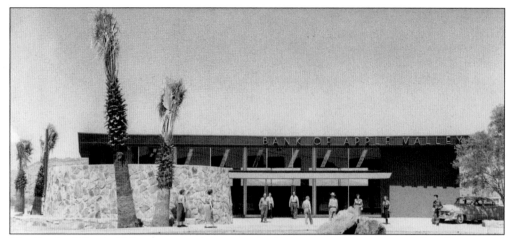

The Bank of Apple Valley was a convenient way for prospective customers to buy houses and obtain other financial goals close to home. The bank was owned by Apple Valley Ranchos, however, which meant that Bass and Westlund had control of their own assets and were privy to information about the assets of many other account holders. (Courtesy Town of Apple Valley.)

The Apple Valley House of Pancakes was a favorite eating spot of Apple Valley residents in the Apple Valley Ranchos heyday. Eva Conrad said that the food was both delicious and affordable. Many area clubs and organization members agreed. (Courtesy Town of Apple Valley.)

The Buffalo Trading Post was a favorite of Apple Valley Inn guests. Owners Zeke and Frances Cornia were well-loved residents and were heavily involved in the creation of what Apple Valley has grown to be. They are remembered today for their large neon-lit buffalo that still stands in the parking lot of the Buffalo Trading Post, even though the store is no longer in operation. The Cornias also built the Black Horse Motel, another famous Apple Valley landmark. (Courtesy Town of Apple Valley.)

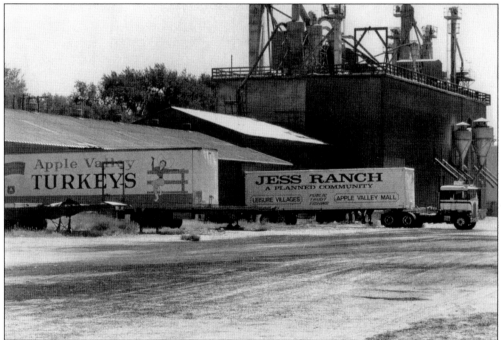

One of Apple Valley's most successful businesses was Jess Ranch Turkey Farm, located in south-central Apple Valley. Jess Ranch was a large-scale operation, delivering thousands of turkeys to American homes for holiday dinners. (Courtesy Victor Valley College.)

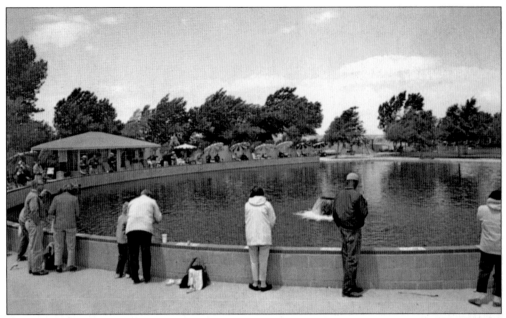

Visitors could visit Jess Ranch to fish in a stocked trout pond. Jess Ranch had two stocked ponds, one for public fishing and one for breeding. (Courtesy Town of Apple Valley.)

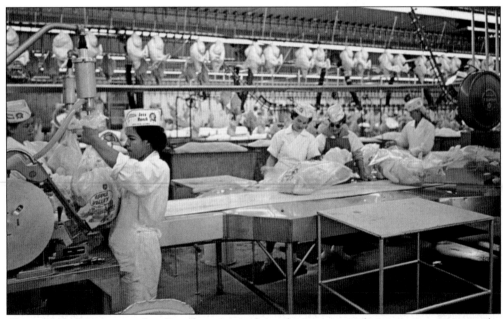

Once a tourist attraction, Jess Ranch was transformed into a senior living environment in the 1990s. Part of the land was used to build a boys home founded by Roy Rogers and Dale Evans. This publicity photograph was used to illustrate the activity inside the ranch's turkey processing plant. (Courtesy Town of Apple Valley.)

Apple Valley was the third and final home of the Terri Lee Doll factory. In 1952, the factory relocated to Apple Valley from Lincoln, Nebraska, after a fire destroyed their operation. The factory, which was located on the corner of Wakita Road and Highway 18, closed its doors for good in 1960. (Courtesy Town of Apple Valley.)

St. Mary Medical Center broke ground in 1954 on land donated to the Catholic Church by Bass and Westlund. The hospital's doors officially opened in 1956. Private donors also contributed more than $220,000 to the hospital's 27-bed facility. (Courtesy Victor Valley College.)

Victorville land developer Clyde Tatum also helped get St. Mary Medical Center off the ground. Ontario, California, architect J. Dewey Harnish planned the hospital's layout and suggested a 27-bed facility, an area for surgery, and laboratory facilities that could eventually be expanded to accommodate 70 beds. (Courtesy Town of Apple Valley.)

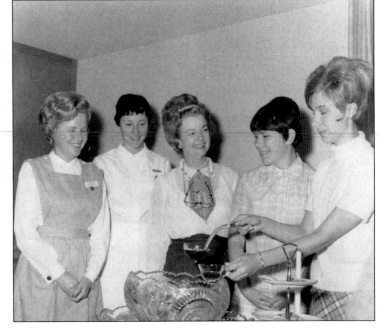

Dale Evans stands at the center of this photograph with a group of candy stripers. Evans was well known as an outgoing Christian woman and was deeply involved with and committed to charity. (Courtesy Town of Apple Valley.)

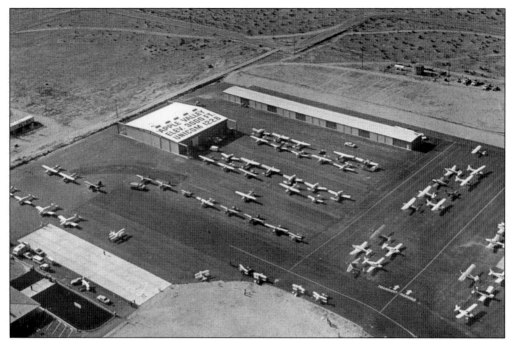

The Apple Valley Airport, which operated in the northern end of Apple Valley, was the former McCarthy Guest Ranch. It originally began as a means for Apple Valley Ranchos to get prospective buyers to the area and turned into a full-fledged airport, accommodating up to 150 planes a weekend. (Courtesy Town of Apple Valley.)

The OTC-XI Spacecraft Company posted this sign in Apple Valley. With research centers in several states across the country, avid space watchers were sure to spot extraterrestrial alien invasion. (Courtesy Town of Apple Valley.)

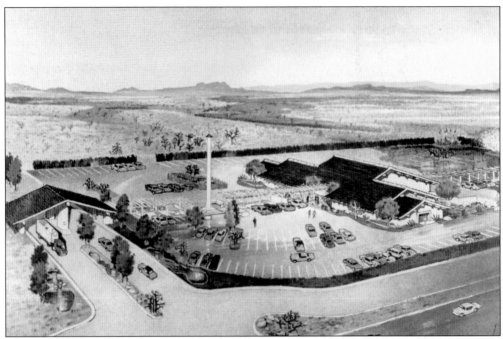

This is an artist's rendering of Victor Valley College, which is located near the border of south-central Apple Valley and Victorville. The college provides thousands of interested minds quality education each year and is home to the local history library, manned by librarian Fran Elgin. (Courtesy Town of Apple Valley.)

Though dedicated community members had worked since 1910 to put Apple Valley on the map via the Apple Valley Improvement Association, the town's chamber of commerce did not see official establishment until the 1940s. (Courtesy Town of Apple Valley.)

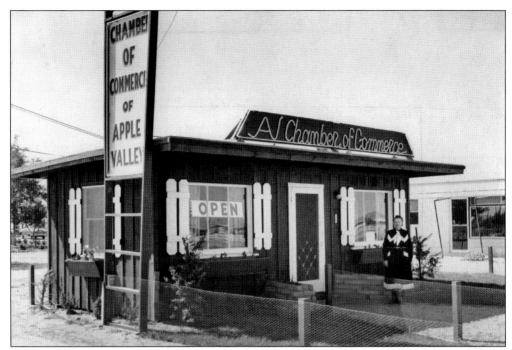

The Apple Valley Ranchos Businessmen's Association was the first official name of the Apple Valley Chamber of Commerce and was established in 1948. It became the Apple Valley Chamber of Commerce in 1951. (Courtesy Town of Apple Valley.)

The businessmen's association held its first community parade and Pow Wow Days carnival in 1948. The chamber-sponsored event included everything from a Ferris wheel to cotton candy to Indian fry bread. Early Pow Wow Days was then held over the course of three days and now spans just one day. (Courtesy Town of Apple Valley.)

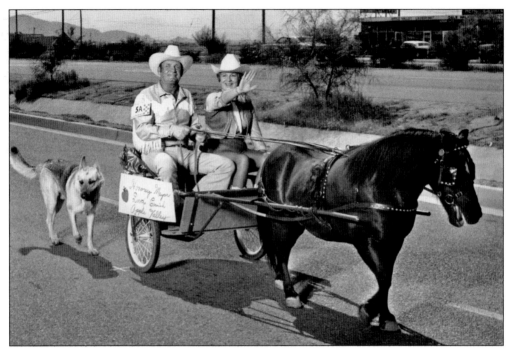

Apple Valley's Pow Wow Days was the centerpiece for the community residents. Clubs and organizations turned out in force to support one other, celebrate their heritage, and showcase their rural lifestyle. (Courtesy Town of Apple Valley.)

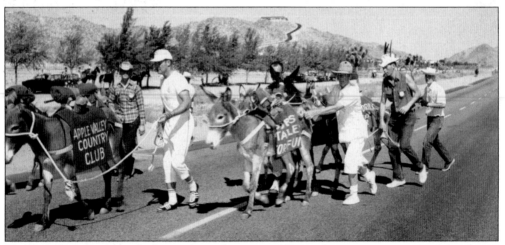

The Pow Wow Days parade featured area horsemen, Native American representatives wearing brilliant feathered headdresses, and homemade floats with teepees, as well as singing and dancing performers. (Courtesy Town of Apple Valley.)

Ten

SOCIAL LIFE

From the earliest days of Apple Valley, one common thread has sewn its residents and guests together. Whether they were on Rancho Yucca Loma, staying at the Apple Valley Inn, or attending a club meeting at the community center, the people who met in Apple Valley shared a strong sense of friendship. (Courtesy Town of Apple Valley.)

This well-dressed unidentified man looks excited about the message painted on the car behind him. Taken in the 1960s, this photograph was collected with a variety of other shots belonging to Apple Valley newspaper publisher Eva Conrad, who passed away in 2001. (Courtesy Town of Apple Valley.)

1950s Baritone crooner John Charles Thomas enjoys a round of golf at the Apple Valley Inn. This photograph was used in one of the famous magazine spreads from Apple Valley Ranchos. (Courtesy Town of Apple Valley.)

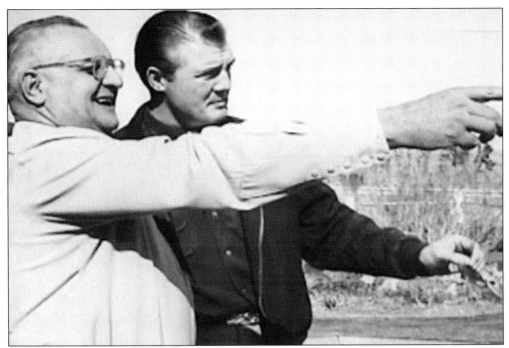

This publicity shot shows Newton Bass (left) and television star George Reeves examining the golf course. Dozens of photographs highlight the variety of stars who enjoyed themselves and one another on the Apple Valley Golf Course. (Courtesy Town of Apple Valley.)

The Apple Valley Lion's Club was the first club organization in Apple Valley, according to Margaret Mendel, whose husband, Al, was a founding member. This 1960s photograph shows Lion's Club members saying a prayer at a local dedication. (Courtesy Town of Apple Valley.)

Apple Valley residents and guests never stopped loving their equestrian roots. Though the sprawling farm lifestyle once prevalent in Apple Valley has been swallowed up by progress, horses and their riders can still be seen in the desert. (Courtesy Town of Apple Valley.)

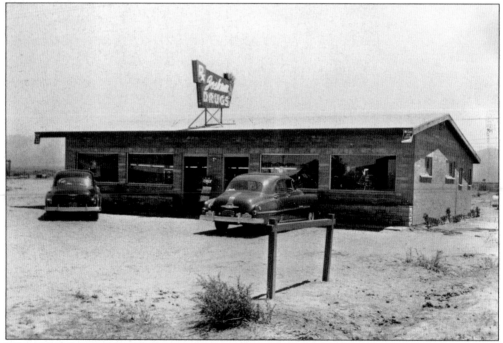

This 1950s photograph of Joshua Drugs in Apple Valley is highlighted by the vintage cars in the parking lot. These beautiful relics can only be seen at classic car shows now. (Courtesy Town of Apple Valley.)

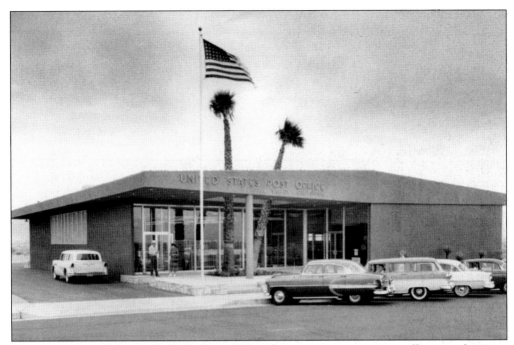

This 1960s shot of the Apple Valley Post Office showcases an interesting collection of vintage cars. Rural postal delivery was not available in Apple Valley, which made the daily trip to the post office an occasion for residents to share a quick hello. (Courtesy Town of Apple Valley.)

The Yucca Loma Elementary School was the first modern school built in Apple Valley. Today the campus also serves as a gathering spot for disadvantaged youth, who can participate in one of the school's many outreach programs. Before- and after-school programs, tutoring, and nutrition programs are available. (Courtesy Town of Apple Valley.)

This architectural rendering of Apple Valley Senior High School shows the sprawling high school campus that now stands in south Apple Valley near the site of the original Apple Valley School. The school's football field is named after Apple Valley's now-famous developer Newton Bass. (Courtesy Town of Apple Valley.)

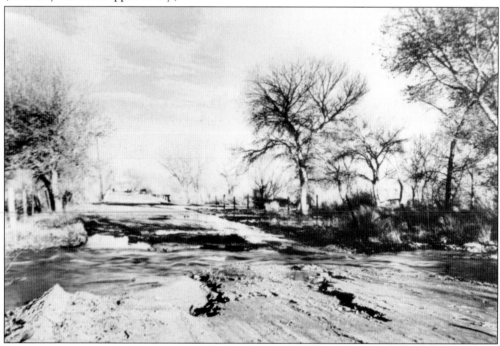

Water streaming in the Mojave River, cropping up in natural springs, and then dipping blow ground once more to flow beneath the soil provided the necessities of life for Apple Valley to exist and grow. It is thanks to that life-giving liquid and the dreams of entrepreneurs that Apple Valley is alive and well today. (Courtesy Town of Apple Valley.)

BIBLIOGRAPHY

Barry, John. Taped oral history interview by John Swisher. Victor Valley College, August 6, 1988.

Bertolotti, Herald. Taped oral history interview by Richard Thompson and Fran Elgin. Victor Valley College, September 7, 2000.

Conrad, Eva. Taped oral history interview. Victor Valley College, June 9, 1993.

Cramer, Maggie. Taped oral history interview by Larry Reese and Richard Thompson. Victor Valley College, October 16, 2001.

Davisson, Barbara. Taped oral history interview by Cheryl Richter and Fran Elgin. Victor Valley College, March 31, 1999.

Gowen, Bertie. Taped oral history interview. Victor Valley College, March 30, 1985.

O' Rourke, Katie. *The History of Apple Valley*. Published through a partnership between the Apple Valley Chamber of Commerce and the Lewis Center for Educational Research, 2002.

Mendel, Margaret. Taped oral history interview. Victor Valley College, January 25, 2001.

Smith, Theodore. Taped oral history interview by Richard Thompson. Victor Valley College, May 10, 2001.

ACROSS AMERICA, PEOPLE ARE DISCOVERING SOMETHING WONDERFUL. *THEIR HERITAGE.*

Arcadia Publishing is the leading local history publisher in the United States. With more than 3,000 titles in print and hundreds of new titles released every year, Arcadia has extensive specialized experience chronicling the history of communities and celebrating America's hidden stories, bringing to life the people, places, and events from the past. To discover the history of other communities across the nation, please visit:

www.arcadiapublishing.com

Customized search tools allow you to find regional history books about the town where you grew up, the cities where your friends and family live, the town where your parents met, or even that retirement spot you've been dreaming about.